Behind Closed Doors

*Her Father's House
and Other Stories
of Sicily*

by

MARIA MESSINA

Translated from the Italian and with an
Introduction and Afterword by Elise Magistro

Preface by Fred Gardaphé

The Feminist Press
at the City University of New York
New York

Published in 2007 by The Feminist Press at the City University of New York
The Graduate Center, 365 Fifth Avenue, Suite 5406, New York, NY 10016

Library of Congress Cataloging-in-Publication Data

Messina, Maria, 1887-1944.
[Short stories. English]
Behind closed doors : Her father's house and other stories of Sicily / by Maria Messina ; translated
and with an introduction and afterword by Elise Magistro. Preface by Fred Gardaphé.
 p. cm.
 ISBN-13: 978-1-55861-552-6 (pbk.); ISBN-10: 1-55861-552-0 (pbk.)
 ISBN-13: 978-1-55861-553-3 (cloth); ISBN-10: 1-55861-553-9 (cloth)
 I. Magistro, Elise. II. Title.
 PQ4829.E7A2 2007
 853'.912—dc22

 2007003928

Text and jacket design by Lisa Force
Jacket photo copyright © 2007 by Giuseppe Ciccia; used by permission of the artist
Printed in Canada

13 12 11 10 09 08 07 5 4 3 2 1

Contents

꿍

Preface

Sicily has been the setting for many foundational myths of physical violence, including those in Homer's *Illiad* and *Odyssey*. Between those master narratives and contemporary mythology about the Mafia's violence lies the reality of Sicilian culture, much of which is still invisible. Early in the last century Sicily provided the United States with a large number of immigrants who have come to be called Italian Americans, and whose lives were seemingly founded on and ruled by still another mythology, that of *destinu* or destiny.

Leonardo Sciascia and other notable writers and intellectuals have written of Sicily's controlling narrative as a psychological *paura storica*, or history of fear, believed fundamental to Sicilian character and also to an important Sicilian school of Italian literature, composed of such writers as Giovanni Verga, Luigi Priandello, Giusseppe di Lampedusa, and Elio Vittorini. For all these writers, the male narrative self is subservient to

the voices of others; the self rarely dominates others; the narrative mask enables the "true" self to remain flexible and hidden behind the story's characters. This is a safe stance for these male authors who sometimes had to survive during turbulent political times.

Maria Messina, a contemporary of Verga, Pirandello, and Lampedusa, challenged these dominant narratives in her time by writing from the perspective of women. Through Messina, we are able to see the effects of a patriarchal system that forces women at all social levels to acquiesce to the men in their lives. Her stories show us what happens inside misperceived silences and explains just how different this notion of destiny was for women compared to men. She takes us into another side of Sicilian irrationality that Sciascia described: "The history of Sicily is one of defeats: defeats of reason, defeats of reasonable men. . . . From that however comes skepticism, that is not, in effect, the acceptance of defeat, but a margin of security, of elasticity, through which the defeat, already expected, already rationalized, does not become definitive and mortal. Skepticism is healthy though. It is the best antidote to fanaticism" (6). Messina's artistry turns irrationality into skepticism and serves as a form of self-empowerment in a land often constricted by the spirit-killing rationality of industrial capitalism, which ultimately sent thousands of Sicilians away from the island forever.

Messina wrote at a time when nearly one-third of the island's population left in search of better lives, but the stories they left behind took almost a century to surface in history and

fiction. Since most immigrants could not write, they told their stories in Italian or in a more obscure dialect few Americans or other Italians could understand. Often their stories died untold, even to their children who were busy becoming Americans. Or, if told, they were dwarfed by the giant myths of men. Through her stories, Messina becomes a firsthand witness, especially to the stories of those who stayed behind, mainly women, and the stories of those who returned brokenhearted, incapacitated, and ready to die.

Inside Messina's stories, alongside peasant life and work and the desire to escape to places like the United States, we also find middle-class daughters forced by convention to remain hidden in their father's houses, isolated in a world they did not create and that they cannot control. These are the stories we have not known, filled with sorrows invisible to those of us celebrating the success of Italian Americans. These stories, repressed by generation after generation and maintained by silence, come to us now through deserved reconsideration of Messina's artistry. They connect us to a past that will change the ways in which we characterize Italian life and immigration.

I heard only vague references, when I was a kid, to those who were left behind or kept behind. I had seen women like the ones in these stories in my Little Italy neighborhood, but I never understood what they may have experienced until I read Messina's stories. As my grandmother used to say, whenever I'd ask her something that obviously pained her, "Why do you want to know about those things; it was *miseria* and we should

forget about it." But Messina records what no *man* had ever recorded—the misery of women whose lives were sacrificed to fear; and the misery of some who left Sicily for the United States; and the misery of others who could not leave—and she does it in a way that makes all that *miseria* matter.

Messina's stories provide a link between women's imagination and women's history, both missing from the historical and literary record. The pure sadness here ultimately transcends that emotion to provide a view of real life in process. Less romantic than Helen Barolini's *Umbertina* and more earthy than the late Tina DeRosa's *Paper Fish*, Messina's stories unleash closely observed realism. Ideas of destiny, *figura*, *omerta*—a man's honor and how a woman reflects it—combine in these stories to reveal and challenge a mythic family structure oppressive to women and ultimately demeaning to men as well, and for too long the basis of the ways in which we have consumed and used Sicilian culture.

These stories, along with more of Messina's work, have gone unread by audiences outside of Italy because, even today, translating the literature of Italian women writers into English has rarely been regarded as important. Magistro's informative Introduction and Afterword situate these beautiful stories historically and aesthetically, opening up possibilities for English readers to investigate what it meant to be a Sicilian woman in the early twentieth century. Magistro has thus rendered a great service by enhancing our understanding of the complexities of female life in Sicily. By taking us inside and beyond the women dressed in black who have for too long represented Sicilian

women in literature, Maria Messina, with Magistro's aid, has diversified the dominant portraits of this island and, in turn, helped to dispel one of the many myths of the Mediterranean.

> Fred Gardaphé
> Stony Brook University
> April 2007

Introduction

In the early twentieth century, Sicily was as deeply divided socially and economically as it had been for much of its long and painful history. While the island's ancient wonders and the splendor of its capital city had made Sicily a *de rigueur* stop on an eighteenth-century Grand Tour, a fascination with Sicily's rich past belied the appalling conditions in which most Sicilians had lived for centuries. Day laborers and peasants with negligible holdings accounted for more than three-quarters of the island's inhabitants, many of whom worked small plots beyond their hillside towns. Others toiled on the vast *latifondi* (ex-feudal estates) of Sicily's remote interior. For these impoverished peasants, life followed an immutable course, governed by the rhythms of the agricultural cycle and punctuated only by births, deaths, epidemics, and ritual celebrations. Bt the time of national unification in 1861, illiteracy on the island still hovered at a staggering 87 percent (Briggs 1978, 38), dropping

only to 58 percent by 1911, numbers that were unparalleled elsewhere in Western Europe (Astorita 2005, 288).

The deep-rooted pessimism that permeated Sicily's peasant class was the result of centuries of neglect and exploitation by foreign rulers. National unification offered guarded hope for meaningful change. Citizens of the new Italy residing in the north-central regions of the country were aware of the political divide that had long separated them from their southern neighbors. Few, however, had any realistic conception of the degree of Sicily's backwardness or the desperation of its people. In four hundred years of Spanish Bourbon rule, the uncontested power of the land barons, coupled with the conspicuous absence of an educated middle class, had perpetuated southern poverty beyond any imaginable measure. Emissaries dispatched to the region after unification were shocked by what they considered the cultural and moral disparity between North and South, their prejudices evidenced in the discriminatory language of their official correspondence (Moe 1992).

Exacerbating Sicilian disillusionment in the post-Unification years was the government's decision to favor northern industrial interests at the expense of the southern masses. Rome's failure to deliver on political promises strengthened the mafia's hold, provoked hostility among impatient Sicilians, and incited violence across the island that horrified even the most sympathetic northern Italian observers. The brutal suppression of Sicilian workers' movements (*i fasci siciliani*) and subsequent imposition of martial law in 1894, capped male estrangement from the political order. As late as 1912, nearly 70 percent of

Sicilian men were still ineligible to vote due to land ownership and literacy requirements (Astorita 2005, 287). Understandably, a sense of fatalism or *destino*, dominated the Sicilian psyche, a reflection of ordinary Sicilians' inability to control the direction of their lives.

On the surface, the formal abolition of feudalism in 1806 and the dissolution of church holdings in 1860 had aimed at a more equitable distribution of lands. However, a new landed elite, anxious to expand their holdings, blocked attempts to redistribute this wealth. Savvy alliances between local landowners and government officials in Rome ensured that little would change despite ostensibly comprehensive reforms. Taxes remained disproportionately high for those least able to pay, and usury was rampant. Owners of smaller plots, shopkeepers, and artisans (the most frequent subjects in Maria Messina's artistic lens), feared losing their financial footing in a climate resistant to social change.

Historian Denis Mack Smith estimates that the average provincial town of 10,000 residents at the turn of the century contained approximately one hundred families of *galantuomini*, gentlemen property owners who constituted the resident ruling class (1968, 427). Mistretta, which serves as the backdrop for a number of Messina's short stories, was typical in this regard. As Smith notes, these men took the title of *don*, spent their days at gentlemen's clubs, and claimed membership in the *civili*, or "civilized class," thus distinguishing themselves as individuals who made their living from the labor of others. Although a mutual dependency between landowners and the lower classes

existed, maintaining social distance from their inferiors and keeping them uneducated remained two of the primary objectives of the *civili* (Foerester 1924, 100).

On the other hand, the compact structure of Sicilian hill towns made a certain degree of intermingling among the classes unavoidable. Regional Sicilian writing of the period offers a varied tapestry of provincial town life in which vendors hawk their wares through narrow streets, women knit and gossip on their doorsteps, and the elite stroll daily along the main *corso*. The *case basse* or low, street-level houses of the poor appear scattered amid more modest two-story dwellings and the multiroom residences of the *civili*. With neighborhoods less rigorously demarcated than Sicilian society itself, distinctive landmarks provided shared communal space. In this respect, Mistretta was representative but also more aesthetically appealing, with its imposing Norman fortress (*il Castello*), graceful Pia Fountain, and public gardens of the Villa Châlet. By way of contrast, author Emanuele Navarro della Miraglia details the bleaker physical aspects of a prototypical Sicilian town in the opening paragraphs of his short story, "*Paese*" (The Village), written in 1885:

> The town I would like to tell you about is one that you might find anywhere in Sicily, but that you would search for in vain on any map. It is called Gibelmoro. . . . It boasts two thousand residences and ten thousand inhabitants, nine tenths of which are peasants. There are very few well-to-do citizens and

not many artisans. The town is spread out across the ridge of a mountain, encircled by fertilizer mounds and prickly pears that scent the surrounding air. It has twenty churches, more than fifty priests—five monasteries for men and three for women.

Theatres, hospitals, homes for the elderly? There are none. . . . Gibelmoro has a road that has been under construction for more than twenty years now, and that will probably not be completed before the new century. For the moment, the town is only accessible by horse, when the river torrents permit, and when the rains have not completely worn away the paths. The internal streets are steep, torturous and narrow, paved with rough white stones or not paved at all. (Navarro della Miraglia 1974, 71–76)

By the turn of the century, more enterprising Sicilians, frustrated with the status quo, began to look beyond Sicily's shores for a long-term solution to their discontent.[1] While many migrated to the North in search of seasonal work, most responded to *La Mèrica*'s increasing demand for both skilled and unskilled labor. Although Sicilians were among the last to leave in the great migration out of Italy between 1880 and 1920, the ultimate intensity of their movement exceeded that of all other regions. What began with a handful of resourceful individuals determined to improve their economic lot mushroomed rapidly into an exodus of staggering proportions, transforming the island into a venue of collective grief. So marked, in fact,

was this movement out of Sicily that in 1906 alone 127,000 of Italy's 200,000 departing emigrants were Sicilian (Foerester 1924, 104). By 1913, an astounding 1 million of the island's 3.5 million residents had departed for foreign shores. While official policy insisted that emigration provided a safety valve for those most affected by a downturn in the southern economy, chiefly disenfranchised day laborers and peasants, more recent scholarship has concluded that others, "who were a little better off and feared themselves to be slipping down the social ladder," were leaving the island as well, draining the South of its most enterprising individuals (Lopreato 1970, 35).

As brother called for brother and father for son, the resulting unprecedented "chain migration" left countless women, children, and elderly parents either temporarily or permanently abandoned. While Mistretta did not suffer the 50 percent male emigration rate experienced by still more depressed areas in Sicily, official registers reflect the phenomenon's impact on small, urbanized centers scattered across the island. Between 1903 and 1909, years that coincided with Maria Messina's residence in Mistretta, 1,517 of its estimated 15,000 citizens departed for American cities, a figure that would reach nearly one-third of the town's population by 1924 ("Centonove" 2006).

For all of its tragic consequences, emigration on a grand scale spurred profound and decidedly positive changes in certain segments of Sicilian society. Cash remittances from across the Atlantic bolstered the flagging economy and facilitated upward mobility for families of emigrants (Cinel 1984, 59–60).

Demands for basic education also soared, as wives and daughters of emigrants emerged from the strict confines of domestic life during their husbands' absence. Activities that a mere generation earlier would have been inconceivable for any proper Sicilian woman were now considered necessity rather than choice. Running small shops, paying taxes, purchasing supplies, and managing more than a family budget, all required basic literacy and mathematical skills. Education—historically considered the realm of the elite and viewed with suspicion by the working classes for its associations with leisure—was now seen as key to socioeconomic advancement (Reeder 1998, 106).

Despite these positive steps, Sicilian society as a whole remained deeply entrenched in its old ways well into the first decades of the century. Birthright and land ownership had always been the visible cornerstones of prestige, and the pursuit of the latter along with solidifying social barriers continued to be the chief preoccupation of *civili* families, few of whom emigrated. It is within this historic context that one may understand why Sicilians of Maria Messina's day, and particularly those of her own struggling class, set great store on outward appearances. In provincial towns, cut off from the social life of urban centers and lacking both a vibrant economy and well-educated citizenry, one's public persona—how one dressed, the venues one frequented, the company one kept, and the relationships one established—was the ultimate barometer of respectability. Most important, the respect one commanded greatly enhanced opportunities to further one's *interesse*, or prospects for one's family's future (Bell 1979, 77–78).

Maintaining an appropriate level of respectability was a contest of self-preservation in Sicily's petit bourgeoisie, a class that included clerks, bureaucrats, teachers, clerics and professionals, many of whom lacked the earning capital to solidify their economic position (Briggs 1978, 16).[2] In a bad year, a small proprietor's land might not produce, a vineyard could be lost to creditors, and debt could rapidly accumulate, making outward appearances difficult to maintain. Any hint of a progressive slide into poverty threatened to erase the respectability a family had painstakingly earned, and its members were acutely aware of possible social consequences. The stigma of poverty and its inevitable association with the lower classes was the driving force behind Sicilians' obsession with appearances, even in the face of devastating misfortune. Families with little more than their dignity intact thus struggled to hide growing economic hardship behind the outer trappings of respectability.[3]

Historically, Sicilian women of all classes were important to this mercurial economic equation, and they suffered disproportionately the consequences of financial hardship. Respectability was quantifiable for Sicilians, and a well-brought up daughter—her conduct, her sobriety, her modesty, her readiness for marriage—were principle indicators of a family's honor. Not surprisingly, parents diligently monitored their daughters' movements in the public sphere, cognizant that any chance encounter with a member of the opposite sex cast suspicion on a daughter's behavior and ultimately compromised her worth. Even the daughter of a modest farmer rarely ventured out unaccompanied, and surveillance was more extreme

among the middle class. Young women of the *basso popolo*, (lower class) who worked in the service of others, were more vulnerable to unsolicited advances, and their honor more easily compromised, since the exigencies of their daily lives brought them into frequent contact with men.

If uncertainty about the future loomed above all else in Sicilian society, this sentiment was magnified for Sicilian women about whose lives we know little.[4] The sanctity of the family, primacy of motherhood, and cult of domesticity were deeply entrenched values in the conservative South, as was uncontested male authority, guaranteeing that women rarely received any education beyond the four years of state mandated instruction. Many, apparently, had no schooling at all. Figures from the 1901 census confirm that 77 percent of all Sicilian women were still illiterate at the turn of the century ("*Ministero di Agricoltura*" 1903, 276–319), leaving most in a position of total dependence on their families. With an exception made for a small number of women who earned a teaching certificate—a sign of social status among middle-class families—Sicilian parents discouraged their daughters from seeking employment of any kind outside the home as this was assumed to signal a family's economic need.[5]

Singular testimony that Sicily remained a stronghold of patriarchy in early-twentieth-century Europe comes to us from Elvira Mancuso, a writer and self-proclaimed feminist from a modest background who went on to direct prestigious scholastic institutions in her native Caltanissetta. Mancuso waged a lonely and highly unusual battle against the misogynist practices of her

Sicilian society, documented in her unpublished memoir and the 1906 novel, *Vecchia storia . . . inverosimile* (An Unlikely, Old Story). In *choosing* not to marry rather than *resigning* herself to marriage, Mancuso defied conventional norms with the explicit intent of freeing herself both culturally and economically from the fate of "domestic tyranny" (Nigro 1990, 164). Mancuso was an anomaly in her conservative, provincial world, an unflinching rebel who provoked scandal by insisting on her right "to discuss with men those topics that have absolutely nothing to do with keeping a house, doing the laundry, or any such related activity" (168).

A rare, anthropological study conducted in 1928 by Margaret Chapman reaffirms Mancuso's revelations of Sicilian society's oppressive attitudes toward women. In *Milocca: A Sicilian Village*, Chapman describes how fundamental matters pertaining to female autonomy—choices regarding education, relationships, marriage, proscribed behavior—had changed little over time in Sicily (Chapman 1971, 30–49).[6] Citing a proverb recorded by Sicilian ethnographer Giuseppe Pitrè, "Blessed is the door out of which goes a dead daughter, and the older she is, the greater the comfort," Chapman explains that such a harsh, if exaggerated, expression of the Sicilian mind-set about females was rooted in the monetary difficulties families experienced in providing dowries for their marriageable daughters (30). Because all families invested in a daughter's dowry and because the family's collective welfare was paramount in all discussions relating to marriage, parents maintained the right to arbitrate the terms of a proposal or to refuse it outright.

Although this was particularly true in smaller towns such as Milocca, where the tradition was well established, arranged marriages in one form or another were the norm at all levels of Sicilian society well into the twentieth century (95–96).[7]

Regional literature of the period again illustrates the overwhelming importance of the dowry in Sicilian society, except for the most destitute, and the implications for women whose families could not adequately provide a means for securing their future.[8] The unlucky few had little choice but to live out their days in the homes of their fathers (the *casa paterna*) or that of a brother if their parents were deceased. This also held true for "house nuns" (*monache di casa*), women who wished to enter convents but who were prevented from doing so either because of poverty (religious orders required a monetary or land contribution equivalent to that of a dowry) or "the unwillingness of their parents to dispense with their services at home" (Chapman 1971, 42).

While land and monetary assets figured prominently in marriage arrangements, the formal centerpiece of a woman's dowry in early-twentieth-century Sicily was still the trousseau, or *corredo*. Begun as soon as a young girl had mastered the arts of sewing, lace work, and embroidery, the *corredo* took years to assemble and its worth was calculated in all marriage negotiations. In his *Customs and Habits of the Sicilian Peasants*, the nineteenth-century Sicilian ethnographer Salvatore Salomone-Marino discusses the ritual washing, laying out, and appraisal of traditional articles—pillowcases, sheets, tablecloths, and undergarments—prior to the wedding (1981,

186–87). Since exceptional skill in the domestic arts was one of the few ways a woman could distinguish herself in Sicilian society, an impressive *corredo* was a source of deep pride and often her most prized possession. Depending on a woman's artistry, the intricacy of the patterns chosen, and the quality of the materials used, the value of the *corredo* could be immeasurable (186–87; Schneider and Schneider 1996, 210).

In theory, the *corredo*, along with the rest of a woman's dowry, remained her property as long as she lived. However, in spite of laws that allegedly protected a woman's inheritance, abuses were not uncommon.[9] Inheritance laws, in fact, often influenced how families proceeded in marriage arrangements. For those intent on consolidating their land holdings, refusing a daughter or sister permission to marry was one way of achieving this end. In reality, the economic benefits for the family were threefold. Land patrimonies remained intact, family members were relieved of a significant financial burden, and daughters who to this point had been viewed as a potential drain on family resources, were now available to take on broader, domestic responsibilities, thus eliminating the need for hired outside help.

Perhaps one of the cruelest social conventions still practiced in Sicily at the turn of the century required women to be confined within the home during periods of bereavement. While tradition dictated that males be in attendance at the *consòlo*, the three- to eight-day requisite mourning period when visitors offered condolences, all understood that men's presence in the fields or the town was indispensable to the

family's survival. As a consequence, the enactment of ritual customs associated with death and the task of demonstrating adequate mourning for the loss of a loved one fell to female family members. Failure to conform to the rigorous protocol of strict mourning meant opening oneself and one's family to reproach and the loss of status.[10]

Following the *consòlo*, the house was closed up with windows shuttered for at least nine months. Grieving women were required to stay out of the public eye and many left the house only to attend early mass, generally at five a.m. Peasant and poorer women were allowed some degree of latitude in this regard since leaving the house to procure food, draw water, and launder clothing at the stream or riverbed was viewed as unavoidable. Custom demanded that children dress in gray, brown, or dark blue, while females who had come of age donned black for specified lengths of time, depending on their relation to the deceased. Generally speaking, strict mourning (*il lutto stretto*) lasted one to two years, though most widows chose to wear black permanently.

Because many middle-class women were uneducated, they spent long months of imposed confinement embroidering and performing menial household chores. Young women, in particular, suffered unduly during extended periods of bereavement, since lack of exposure to sun and fresh air heightened their sense of isolation and ultimately weakened their physical and mental health.

The short stories of Sicilian writer Maria Messina (1887–1944) grew from her observations of life in Mistretta, the

provincial Sicilian town where she spent her formative years. Although Messina set a handful of her mature novels in continental Italy, Sicily remained her point of reference and sentimental touchstone through a twenty-year writing career. A proponent of Italian *verismo* (a form of realism), Messina focused on Sicily's repressive treatment of women and the human toll—especially on women—wrought by mass emigration to the Americas.[10]

A Note on the Translation

Any translator of Messina's prose must take into account the author's steadfast allegiance to the principles of Italian *verismo*, as both the content and style of this school of writing profoundly influenced her work. In the 1880's, the most prominent Italian *verista*, Sicilian Giovanni Verga, was in search of "a fresh human content and a style to render it in the best possible way" (Cecchetti 1973, vii). Committed to the representation of the real as opposed to the ideal, Verga and other prominent *veristi* turned to the regions of their youth for inspiration. In these economically depressed and politically neglected regions, the *veristi* focused on individuals at the lowest rung of the socioeconomic ladder, locked in a daily struggle for survival amid poverty, ignorance, and immense human suffering.

Rejecting the bourgeoisie idiom as ill fitted to the cultural world of illiterate peasants and fisherman, the *veristi* sought out new forms of linguistic expression that would convey the essence of their realities. But since most of their subjects spoke exclusively in dialects, the *veristi* faced a perplexing dilemma.

If transcribed faithfully, dialects would have been incomprehensible to mainstream readers. How could they portray the "real" world of their characters using standardized Italian, a language their subjects did not speak?

Verga's solution was to fuse content and style by employing techniques that approximated the colorful speech of his humble characters. This innovative approach to writing demanded that language be unembellished and devoid of contrivance. The salient features of the style were the frequent use of proverbs and regional expressions, the altering of standard syntax to approximate dialect, the presence of an impersonal third-person narrator who is privy to the details of village life and who acts as an intermediary for the reader, and finally the use of free indirect discourse. As Verga scholar Giovanni Cecchetti notes, "Certain cadences and certain rhythms . . . evoke an environment and a way of life belonging only to Sicilians. The syntax is extremely simple, its structure consisting chiefly of a seemingly unending sequence of coordinate clauses linked together by the conjunction 'and'" (Cecchetti 1978, 50).

Guided by these stylistic precepts, when writing of a peasant population, Messina intersperses short, clipped sentences with longer passages to convey the speech and thought patterns of a predominantly illiterate class. Her use of free indirect discourse creates the illusion of characters "narrating themselves," though at times it is difficult—in both the original Italian and the translation—to distinguish where a character's voice ends and that of the impersonal narrator begins. In the second story in this collection, *"La Mèrica,"* Messina writes: "'And your

things?' Her things? Obviously Mamma Vita had no idea of what a city is like! Who could open a suitcase and look for things in the midst of that hell?" (*Piccoli gorghi* 1997, 106). This style is particularly characteristic of the first five stories translated in the current volume, since their content deals explicitly with an unsophisticated peasant world far removed from modern sensibilities.

In the balance of the volume's stories, all of which focus on the repressive nature of middle-class female existence, Messina aims at a similar fusion of style and content, molding the principles of *verismo* to depict a Sicilian reality unknown to her reading public. Gone are the lively banter and colorful outer aspects of village life. The protagonists in these stories are psychologically and physically isolated Sicilian women, governed by rigid codes of behavior and conditioned to silence. Stylistically, Messina renders this fear of speaking out and inability to communicate in unfinished sentences that trail off into a series of ellipses and in the use of frequent internal monologues. Although such writing may appear disjointed to readers accustomed to smooth transitions, its explicit purpose was to adhere to the world of the characters.

A second problem for the translator involves the occasional duality of languages used in the texts. Because Messina aimed at portraying Sicilian life in the most authentic terms possible, she occasionally used Sicilian expressions to color her writing, at times translating the words, songs, or rhymes into standard Italian in the form of footnotes. With the exception of words that have a particular significance in a given

story, I have translated Messina's Sicilian into English, thus eliminating the problem of a "double translation" for the reader. Words left untouched in the Sicilian or Italian are collected in the glossary at the close of this volume. Given the hierarchical structure of Sicilian society, I have also left unchanged the forms of address that indicated one's social rank in the community and that Sicilians used in their dealings with one another. These titles are also defined in the glossary.

Finally, Messina's efforts to transcribe the world as seen through the eyes of her characters extend to her use of metaphors and similes. A kind-hearted, morally solid individual is "as good as bread" (not gold) reflecting peasants' association with their most precious staple. Likewise, an able-bodied, handsome son who inspires pride in his parents is "as beautiful as a banner in the breeze." Although such expressions may strike the modern reader as odd, the images were born out of a particular cultural context, and I have left them unaltered in my translation.

Notes

1. Skilled artisans—tailors, shoemakers, barbers, stonemasons, weavers, and carpenters—were among the first to leave Sicily. Although artisans by definition were a class unto themselves, a great range existed within their ranks. As a group, they were among the first to take advantage of education reforms in Sicilian society as well as the first to form mutual aid societies (Briggs 1978). Of those who remained in Sicily, the most successful aspired to the ranks of the *civili* while others never advanced beyond the petite bourgeoisie. For a thorough discussion of artisans and emigration see Gabaccia (1998).

2. Briggs notes that the range of middle positions in the social structure of southern Italian village society varied significantly.

[Many] were small producers, craftsmen, artisans and agriculturists whose traditional statuses were most affected by modernization and industrialization which rippled through their rural society. By self-ascription, they were the honest and respectable working classes who were distinguished from those above them by earning their livelihoods from their own labors and from those below, the day laborers, by their traditional status derived from the possession of skills, or the ownership of land or other agricultural resources. Class terms carry modern meanings which are not appropriate for the society under consideration. . . . The proletarian overtones of working class should not be applied to these segments of the society. They were certainly not part of the capitalistic bourgeoisie, a class present only in small numbers in the larger cities of the South. Nor will middle class serve to identify these workers. (1978)

3. Jane and Peter Schneider's research of the period confirms that "umbrellas, woolen suits, berets, shoes, stockings, and tobacco were predictable items in even the tightest family budget" (Schneider and Schneider 1996, 130).

4. While feminist scholars in Italy have made great strides over the last thirty years in recovering women's texts and bringing to light the many forgotten contributions of Italian women, there has been no such comparable progress in Sicily. The near total absence of women in the pages of Sicily's literary and social histories has not only hampered the process of recovery but also discouraged many scholars from undertaking such a daunting task. The recently published *Dizionario biografico Siciliane* (EMAROM: Siracusa, 2006) is the first comprehensive work to reconstruct the biographies of notable Sicilian females from the Middle Ages to the early nineteen hundreds.

5. Emigration radically affected the practice rather than the fundamental attitude toward women working outside the home, and much the same could be said of women and education. Regarding the former, jobs

comparable to those available in Italy's industrialized North where women worked in factories, telegraph offices, and small businesses, were nonexistent in Sicily's provincial towns. If Sicilian women worked in greater numbers during intense periods of emigration, this work was primarily family related and not comparable to a broader presence in any kind of organized workforce. As a consequence, strong cultural biases against women working continued to hold sway in the more conservative elements of Sicilian society. As for the latter, Sicilian parents generally remained suspicious of overeducating their children, and especially their daughters whom they eventually hoped would marry and settle into domestic life. See Elvira Mancuso, *Vecchia storia . . . inverosimile* (An Unlikely, Old Story [1990]).

6. Margaret Chapman conducted a year of doctoral research in the remote village of Milocca in 1928. While Chapman completed the actual dissertation in 1935, the manuscript was lost over time and resurfaced only some thirty years later. Finally published in 1971, it is now widely regarded as an important early contribution to the field of cultural anthropology.

7. However shocking to our modern sensibilities, daughters appear to have accepted this state of affairs, even when betrothed to men with whom they were barely, if at all acquainted. Chapman notes that in most cases, "objection is not expected, and is only occasionally made" (94).

8. Even poorer families made every effort to provide some form of dowry for their daughters. Such is the case for the protagonist's mother in Elvira Mancuso's *Una vecchia storia inverosimile.*

> She was a poor widow who had toiled for years to provide bread for herself and her daughter and had managed, through so many sacrifices, to keep her in elementary school, always with the hope that one day she would become a teacher. She would have loved—oh, how she would have loved!—to see her married, too. But having learned the hard way what it meant to be a widow and to live without bread, with a baby in her arms, she was reluctant to give her daughter in marriage to a poor day laborer. On the other hand, there was little hope that her daughter would marry a shopkeeper—or

anyone well to do—because, as she always used to say, those who have material things only look for more. And her daughter had claim to nothing other than the hovel they lived in. Nor had the poor woman managed, for all of her efforts, to put together any sort of *corredo*. (Mancuso 1990, 12)

9. Mancuso inveighed against the system, noting that she, a Sicilian woman, had earned "a respectable, honorable position . . . certainly worth far more, economically and morally, than an ostentatious dowry handed over by her father—a dowry that conferred on her no rights, a dowry that she could neither touch nor administrate" (1990, 166).

10. My information on traditional mourning customs in Sicily comes primarily from interviews conducted in Mistretta in 2005 and 2006 with town historians Professor Antonino Testagrossa, Nella Faillaci, and Giuseppe Ciccia. All are involved with the *Progetto Mistretta*, a civic organization dedicated to the preservation of Mistretta's historic, artistic, and cultural patrimony.

Works Cited

Astorita, Tommaso. 2005. *Between Salt Water and Holy Water: A History of Southern Italy*. New York: W.W. Norton.

Bell, Rudolph. 1979. *Fate and Honor, Family and Village: Demographic and Cultural Change in Rural Italy Since 1800*. Chicago: University of Chicago Press.

Briggs, John. 1978. *An Italian Passage: Immigrants to Three American Cities, 1890–1930*. New Haven: Yale University Press.

Cecchetti, Giovanni. 1973. *The She-Wolf and Other Stories*. Berkeley, Los Angeles, London: University of California Press.

"Centonove." "Inseguendo il sogno americano." 27 ottobre, 2006. Messina, Sicily.

Chapman, Charlotte. 1971. *Milocca: A Sicilian Village*. Chicago: Schenkman.

Cinel, Dino. 1984. "Land Tenure Systems, Return Migration and Militancy in Italy." The Journal of Ethnic Studies, 12:3 (Fall, 1984): 55–74.

Foerester, Robert. 1924. *The Italian Immigration of Our Times*. Cambridge: Harvard University Press.

Gabaccia, Donna. 1988. *Militants and Migrants: Rural Sicilians Become American Workers*. New Bruswick, New Jersey: Rutgers University Press.

Lopreato, Joseph. 1970. *Italian Americans*. New York: Random House.

Mack Smith, Denis. 1968. *Modern Sicily after 1713*, vol. 2 of *A History of Sicily*. New York: The Viking Press.

Mancuso, Elvira. 1906. *Annuzza la maestrina. (Vecchia storia... inverosimile)*. Caltanissetta: Tipografia dell'Omnibus. Rpt. 1990. *Vecchia storia ... inverosimile*. Palermo: Sellerio.

Messina, Maria. 1997. *Piccoli gorghi*. Palermo: Sandron, 1911. Reprint. Palermo: Sellerio.

Navarro della Miraglia, Emanuele. 1885. *Storielle siciliane*. Catania: Gianotta. Rpt. 1974. Palermo: Sellerio

Nigro, Salvatore. 1990. "Una volpicina tra i villani." *In Vecchia storia... inverosimile*. Palermo: Sellerio.

Ministero di Agricoltura, Industria e Commercio, Direzione Generale della Statistica. "Censimento della popolazione del regno al 10 febbraio, 1901." II, 1903. Rome.

Reeder, Linda. "Women in the Classroom: Mass Migration, Literacy and the Nationalization of Sicilian Women at the Turn of the Century," Journal of Social History, 32, (Fall 1998): 101–23.

Salomone-Marino, Salvatore. 1981. *Customs and Habits of the Sicilian Peasants*. Translated by Rosalie N. Norris. London: Associated University Presses.

Schneider, Jane, and Peter T. Schneider. 1996. *Festival of the Poor: Fertility Decline and the Ideology of Class in Sicily, 1860–1980*. Tucson: University of Arizona Press.

Grace

❧

Grazia

The women were out enjoying the sun. *Gna'* Basila, who was crossing red and turquoise sock yarns, and Elena la Mottese, hands folded behind her neck, had their kerchiefs pulled low over their eyes to shield them from the light. They were sitting on an old log propped against the wall that had been there for who knows how many years, worn smooth by water and dried by the sun. Grace, her head uncovered, was sitting a little further off on her doorstep, carefully mending a worn-out shirt. She didn't dare put a kerchief on for fear the neighbor women would make fun of her. She'd already gotten so much sun washing at Buscardo that by now her face and neck, naturally thin and dark, were just like the old log, eroded by water and dried out by the sun.

"You just get drowsy and feel like sleeping in this heat!" said *gna'* Basila, scratching her head with the tip of her knitting needle.

"It's no weather to be working in . . ." replied Elena,

yawning. She picked up the piece of mirror she had brought along with a comb, removed her kerchief, and began to slowly undo her long, thick, chestnut braids, looking at herself in the mirror that she now held tightly between her knees. Once the braids were undone, she shook them loose and began to comb her beautiful hair—slowly—dividing it into two sections, bending her head to the side with every stroke of the comb. And her hair, so smooth and shiny, shimmered in the sun like gold. Grace mended the shirt without saying a word, stealing glances at Elena whenever she threaded her needle.

"Is everything in your life as good as it looks in that mirror?" asked *gna'* Basila.

"I'm doing just fine, thank you very much," replied la Mottese, gripping the teeth of the comb between her thumb and index finger to remove the hair and bits of dandruff that had accumulated. "And why shouldn't I be? He's good, there's no doubt about that. He's not rich like *don* Calòjero or a gentleman like *don* Antonino, I'll grant you, but he gives me everything I need."

She grasped the ends of her hair and shook them lightly, as if there were dust on them; then she began combing her hair again, ever so slowly, tipping her head to the side:

"I know how men expect to be treated by women. You serve your master, and you serve him in bed, too."

"And you brag about it!" exclaimed *gna'* Basila with a smirk.

"And why not? You have to do something to get by, isn't that true, Grace?"

Grace coughed and called Vastianedda.

"You've got to do something," started up Elena again. "Everything depends on what happens. You happened to find a husband, and now you've got to put up with him like he is. Me, on the other hand," and she laughed heartily, revealing brilliant white teeth between lips as red as fire, "me, whoever loves me is my husband, and whoever treats me badly . . . people should just mind their own business."

Gna' Basila would have liked to show how shocked she was but was afraid if she irritated la Motesse, who'd been in Mistretta for three years now and knew everything about everybody, something bad might happen to her. So she held back and only muttered, "Well, if that's the way you see it, count as many as you want!"

But la Mottese, who knew everyone's business, gave her a hard look. "There are those who count and those who don't count."

Vastianedda arrived running, all out of breath; she whispered something to Grace, who in turn quickly folded the shirt and got to her feet, saying, "Will you two be here for a while?"

"And why shouldn't we?"

"Well, then, go sit a little further away."

"What, are you holding a reception?" asked *gna'* Basila, laughing.

"She's expecting Gemello," explained Elena, braiding her long hair. "She's afraid we'll steal him from her. But I have to finish combing my hair, and besides, you don't own the street."

"This stretch in front of my doorstep is mine."

"Fence it off then."

The women laughed. Grace entered the house, shoving Vastianedda ahead of her. It was useless to answer back; it wouldn't have gained her a thing. To get her to argue you'd have to be scratching her eyes out, and they did just that, even in her own house. They insulted her without reason. When someone lost a chicken in the neighborhood it was always her fault. That bothered her more than anything. And then they would say she was quarrelsome and loud by nature. She shouted, yes she shouted and screamed and pulled at her hair as though she had moon sickness, but only when they cornered her. And everyone had a great time making fun of her because they saw how ragged she was, how poor, how ugly. Yes, ugly, too. The Lord couldn't have made her any worse.

And then the others, well, they all had someone to defend them. When *gna'* Basila came home to find her door smeared with dung and lime, she locked herself inside, and it was her husband who went after everyone in the neighborhood, making a terrible scene. And when *gna'* Filippa offended Elena for something having to do with four eggs, *don* Brasi went straight to her house and threw those insults right back at her, even threatening to take legal action. Only Grace never had protection or justice. When she would tell Gemello that they'd accused her of stealing chickens or abused her in some way, he'd say, "So why do you let yourself be treated like that? Either they're right or you're an idiot."

And if Grace tried to prove her innocence or cried, he

shouted that he didn't want to be bothered with it, that he came to her house to get some rest, and that if he had to hear about making enemies or watch those scenes, he just wouldn't come anymore. This threat quieted her down faster than a good beating. She labored day and night, on holidays and during the week. She went to Buscardo to do laundry; for a crust of bread or two coins she would sweep out stables and haul manure all the way out to the country. She toiled, and there were some days when she would drag herself along like an old tired mule because she'd just gotten out of the hospital, alive only because of a miracle. She supported Gemello and his four big hunting dogs, too, animals that no amount of bread could satisfy. Oftentimes she and Vastianedda went without eating just so they could feed those beasts. Whatever she earned, it all went to Gemello. She trembled when she saw him coming, tired and angry with his hunting sack empty, fearing the blows, especially when she had no money or soup for him. But if he came back from hunting with his sack full of meat, Gemello only went looking for Vastianedda so he could give her the dogs, who were tired and starving, while he went off to sell his catch, and you could never find him, not even in the town square. Then Grace would cry and shout and take it out on Vastianedda, especially now that the orphan was almost seven years old and the seven *lire* a month the state gave her to care for the child were about to end. In her desperation she screamed that she would never again open her door to Gemello; that she would spit in his face. But when he really did return, Grace would become humble and fearful like always

and have her hard-earned money ready for him and take off his shirt to wash and his shoes to polish. And when Gemello beat her and threatened to leave her, she would wrap her skinny arms around his legs and drag herself along the floor like a begging dog, paying no attention to the stick raised above her head while Vastianedda tore at her short disheveled hair and yelled, "My mother! He's killing my mother!"

No amount of money was enough for Gemello. The few things she owned, she'd given away, little by little for a song: camisoles, blankets, her hoop earrings, even her holiday bodices and skirts, because plain old work just wasn't enough. It wasn't enough, and when there wasn't a cent left in the house and the fire had gone out and Gemello would show up with his surly face, it was the most frightening sight in the world. Gemello didn't eat just bread.

"What do you take me for? Some kind of beggar desperate for bread?"

Certain things *gna'* Basila just didn't understand. With seven *lire* a month from the state and working every day, you could live the good life, dress decently and eat something hot every evening, instead of killing yourself for a bum who was ashamed of you. With her red-rimmed eyes opened wide, Grace would say right to *gna'* Basila's face, just to convince herself that the other woman believed it, too: "It's not true. When he's not angry he loves me. You can tell. And besides . . . men are men."

Just as long as he loved her, even a little, but forever. When they really wanted to get under her skin, they would tell her

that Gemello was negotiating to marry Rosa, *mastro* Nele's daughter, who had thirty gold coins of dowry, because Gemello was young and he couldn't spend his life tied down to an ugly monkey like Grace. And she believed them. She would laugh aloud, an ugly laugh with her mouth twisting the way it did when the sickness struck her; and then she wanted to know from Gemello if it was true, whimpering to him for days on end that he wouldn't be treated better in any other house, until the irritated man finally beat her.

Now that la Mottese had come to live nearby, Grace no longer had any peace. And she would send Vastianedda even more often to spy on Gemello, warning her not to let herself be seen. And when the orphan didn't have exact information or couldn't track him down or—hungry as she always was—went looking for bread instead of obeying, Grace would grab her by the hair and beat her savagely in a hysterical fury.

In her threadbare, faded red dress, she really must have looked like an ugly monkey, and would eye la Mottese with envy. She coveted her colored corsets braided in gold, her beautiful skirts, her shoes that were always new, and her red and turquoise stockings. Compared to la Motesse, what was she? La Motesse was young, with hair as soft as silk, rosy cheeks, and a beautiful body. Her tight-fitting corsets set off her youthful, firm breasts, and when she washed her face in front of her doorstep, splashing water outside the bucket, all fresh and rosy and happy, you could see parts of her neck and arms that were as white as wax. And so Grace was ashamed to be seen doing laundry with the loose skin of her rail-thin arms

exposed and would then find all kinds of excuses to beat Vastianedda. She was aware that Gemello liked joking with la Mottese, who laughed at anything, and it gnawed at her.

And on this day, too, Elena had come to comb her hair in the sun right in front of her house. When Gemello arrived playing his flute and humming, Grace bit her lip and began shouting at Vastianedda, staring with half-crazed, hysterical eyes at Elena's beautiful chestnut hair shining in the sun. That hair shimmered, filling the entire street with light.

But Gemello wasn't cheating on her with la Mottese, no. Who would ever have suspected *gna'* Basila, that good wife? She, the one who always put on such a pious face when Grace complained and who always raised her eyes to the heavens, scandalized that anyone could love such a bum; it was she who was filling his pockets with money. She was the reason why Gemello had gone weeks and weeks without hunting.

And when one evening Vastianedda came to tell her that she had seen Gemello go into *gna'* Basila's house, Grace went straight away to hide behind the entryway, never feeling the piercing cold, waiting for Gemello to come out. It was very late when the neighbors heard the cries of the child, who was screaming:

"Mamma! Mamma!"

• • •

Early that morning the woman headed out to Buscardo to wash with a black eye and a slow step. Vastianedda followed with a bundle on her head, looking up at her mother to make

sure she didn't see her nibbling on a crust of bread. But Grace wasn't even aware of her presence.

She spent the entire day at Buscardo washing mechanically, bent over the stream's shore out in the open. At times she thought, and at times she felt herself becoming sleepy and lifeless, like when your eyes are half closed in a cart bumping along the cobblestones on the main street. She stayed there awhile, her hands stiff with cold in water that was clouded by soapsuds. Little by little the water cleared, and the bubbles slowly disappeared, carried downstream by the current that was always the same, always the same. And if she were to expose *gna'* Basila . . . Gemello would just beat her again, worse than ever, and *don* Liborio, the happy husband of that evil woman, would give her the rest. Who would help her, so alone in the world, so alone and poor and ugly?

She looked at her emaciated arms and her red dress. She saw herself and felt as she never had before, small and stooped in the midst of the vast countryside on the shore of the stream that always ran its same course. And what if Gemello didn't come back? If he had left her forever?

America 1911

❧

La Mèrica

And then others passed, more than thirty:
young men spread out in a swarm like bees;
It seemed to me the darkness had swallowed them up,
one by one, and that the wind,
and that fog that drags across the earth
had scattered them throughout the world.
The dark pulled them away; an uproar,
a chattering, and names, and shouts and cries:
A voice that sang with all its might,
but there was so much anger in that voice,
the desperation and the sorrow
that seemed to curse heaven and earth.
—Vito Mercadante, *"Focu di Mungibeddu"* (Etna's Fire)

Mariano announced it on the evening of Saint Michael's Day
when he arrived home from Baronia with his aging father.
Catena, who was nursing the baby, turned white as a dead

woman and said, "So they've managed to put it into your head, those troublemakers! Well, if you really want to go, you'd better know that I didn't get married just to end up a widow or stay a girl after one year of marriage!"

Mariano angrily threw his hoe down in the corner, cursing; Catena shook her head and with pale lips repeated, "I'm coming. I'm coming, or I'll throw myself off the top of the Castle!"

Returning from the stable, Mamma Vita found them arguing. When they quarreled like that, she never said a word, out of prudence, but seeing them so agitated and hearing the words *La Mèrica*, fear gripped her heart, and she murmured, "My son, what are you saying?"

She was hunched over in the doorway, black and tiny, with a fistful of straw in her raised apron, and Mariano, feeling himself watched by those clear, frightened eyes, composed himself and said, "I'm just doing what everyone else in Amarelli is doing, and this one is tormenting me with her all whining. Just see if it's possible for someone like Catena to leave."

Mamma Vita didn't move, as though she didn't comprehend. Then she bent over the wood chest, covering her face with her hands. With the toddler now asleep on her lap, Catena stared blankly ahead, her enormous black eyes full of passion and pain. Finally, the old man came up, too. He knew about his son's sad decision and went toward the stairs without saying a word.

Everyone in the neighborhood of Amarelli was leaving, and there was weeping in every house. It was like wartime, and

just as when there is war, wives were left without husbands and mothers without sons.

Gna' Maria, that old woman with white hair ruffled like wool on a distaff, wailed in misery at her doorstep, not caring who heard her, crying out the names of her two sons with her raised hands, cursing *La Mèrica* with all her soul. La Varvarissa, so young and with a tiny creature at her breast, was left without a husband; and the only son of *mastro* Antonino was leaving, too; and Ciccio Spiga, and the husband of Maruzza, the blond. . . . Who could count them all? Everyone was leaving, and in the houses in mourning the women were left to weep. And yet each one of them owned something, a piece of land, a *quota*, a house, and still they were going. The best young men of the village were leaving to work in that enchanted land that enticed them like a seductress.

Now Mariano, too. And Mariano had a little farm that provided them with oil and bread, a bit of land hoed and tended like a garden, and a beautiful young wife, sweet as honey. What they'd done to keep him from leaving, to get the idea of *La Mèrica* out of his head, no one could even remember. He'd wanted a mule, and *ssù* 'Ntoni bought him one; Mamma Vita had sewn him another velvet suit, and Catena simply hadn't known what to say or do to keep him near.

But *La Mèrica*, said *gna'* Maria, is a woodworm that eats away at things, a sickness that attacks, and when the time comes for a man to buy a suitcase, there's nothing that can hold him back.

On that gray Saint Michael's evening, the elderly parents

knew that this moment had come for Mariano, too.

But Catena, her eyes staring straight ahead, wouldn't hear of being left behind. With her small olive face darkened by passion and fear, she was thinking about following her husband. She was thinking, and it felt like the thought was a wound or a fever so much did her head and heart ache.

After that horrible evening and the days that followed, she kept on, begging with her eyes and threatening with her voice. "I'm coming. If you leave, I'm leaving, too. I'll throw myself off the Castle. . . ."

Mamma Vita couldn't blame her. "It's only right, it's only right," she would repeat in a resigned voice.

"But the baby!" shouted Mariano, becoming irritated because his mother was now contradicting him, too.

The baby! It was true. Couldn't a long voyage like that kill a little one?

"Oh," implored Catena. "Am I not a mother? I'll keep him wrapped in my shawl, keep him close to my breast just like a little bird in a nest. There's nothing to worry about."

What sad days. Husband and wife did nothing but argue. But then Catena won out, and when Mariano bought the expandable suitcase and started putting his things together, Catena, trembling but decisive, organized her things along with those of the baby.

Her pale face had the look of a terrified child. She spied on everything and everyone, fearful till the last minute that something unforeseen, some betrayal on Mariano's part, might keep her from leaving. And in the suitcases she frantically

mixed in his things with hers to make sure he wouldn't be leaving without her.

It was only on the night that the bags were ready and Mariano showed her the two tickets that she calmed down, and her eyes became sweet and laughing again the way they had always been.

And it was then that she began to feel the pain of leaving, and she felt like a thousand years would have to pass before the time would finally come to leave the little house where she'd been so happy for a year, after the ill treatment she had suffered in the house of her stepfather and stepsister, to leave a tearful Mamma Vita, who had been a mother to her, and Papà 'Ntoni, who suffered in silence.

When they had gone, *ssù* 'Ntoni went back to the farm: You don't just abandon the land.

As always, Mamma Vita helped him load the donkey, and she gave him his bread.

"I'm not coming," she added. "It's the same as if they'd given me a good beating."

Hunched over, she went back into the house and closed the door and the window the way you do when someone dies.

"What will I do from now on?" she thought, looking around. "I had two little bees buzzing about, and now they've flown away."

What good was it to work the land? What good was there in spinning flax and weaving cloth anymore? She thought sadly of old 'Ntoni, alone and sick, planting good golden grain up there in Baronia on a beautiful piece of sunny land that their

son had appreciated so little. And she relived the previous night's scene. They had left at midnight; there was no moon, and you could barely make out the two carts readied in the wide street, already filled with other emigrants, the loaded carts that had gone off in the dark night with the song of the young people and the jingle of a baby's rattle.

"My poor children!" she sighed heavily, her heart breaking.

While unloading the donkey that evening, *ssù* 'Ntoni repeated, "Vita, the land needs strong arms, and I'm old, I'm not enough."

"I know," answered *gna'* Vita, "but I want to wait for the letter. How can I think about the farm when I don't even know if those poor creatures have left yet?"

Her heart was telling her that. In fact, the letter from Palermo brought strange and unexpected news.

The postman read it to her, and after, she held it for a long time in her hands, poor and ignorant hands, burnished and weathered from labor and age, looking at the few black and twisted lines as though she could understand their meaning.

"There's no end to the bad news," she said sadly to her husband that evening. "That son of ours, beautiful as a banner in the breeze, is leaving, and his wife is coming back."

So much for planting and the farm! Now she would be tied down, no longer able to follow her husband, who needed help, up in Baronia. What could you get done up there with a young mother and an infant?

• • •

Catena returned in the evening by coach. Drawn and unkempt, with ashen lips and glazed eyes, she appeared sick, as though she had a fever. She set the child on the bed and sank down on the wood bench disconsolate, her arms on her knees. Mamma Vita took the crying baby to try to calm him, and holding him again so close to her breast, she felt a great tenderness, as though with that sweet creature a part of Mariano had come back to her.

"What happened, Catena?" she asked.

Her daughter-in-law did not reply.

"What about the others, Catena?"

Her daughter-in-law kept silent. The baby cried louder because he was hungry.

"Give him to me," she said brusquely.

"No, your milk is no good now. Do you think I don't understand you?"

The slow, trembling voice of the old woman penetrated her heart, and Catena began to weep and speak confusedly, gradually calming down as she poured out her emotions.

It had been a day from hell. There were twenty-five of them, including that horrible stepsister of hers. And everyone was in the streets, the big city streets, dazed by the noise, blinded by the dust, and tired, so tired, that they could've thrown themselves down to sleep on the ground, and all of them there together, frightened, like souls in Purgatory, as if they had no homes of their own back in the village; dodging carriages with or without horses that would have run over a Christian just like that, sent back by the steamship, sent back

by the doctor who was supposed to examine them. Finally, he'd checked them, one by one. She'd been the last and had gone with confidence after all the others had been accepted.

"And then . . . *you know*?" she shouted, "after the shame of having to be examined by that strange doctor, to have to hear that there's something wrong with your eyes! Me! My eyes that have always been the envy of everyone!"

She spoke without finishing words, in halting phrases broken by sobs that wracked her chest.

"No, I didn't cry there. No. Instead I wrote to you. I have nobody. No mother, no brothers, no one. I watched them board the steamer, all of them, one by one. Even that one, *her*, you know, who laughed in my face as she waved good-bye!"

And Mariano? Not even one kind word, not one single word of encouragement! Oh, of course he'd thought about her return ticket, that of course, so that as soon as the ship had left, someone from the station accompanied her to the train.

"And your things?"

Her things? Obviously, Mamma Vita had no idea of what a city was like! Who could open a suitcase and look for things in the midst of that hell?

She showed her mother-in-law the prescription. The doctor had given it to her. Every morning it would be necessary to put a few drops of the prescribed medication in each eye; a pharmacist could administer it, or any trained person.

"He assured me that after a month's treatment I'll be cured."

"You see," exclaimed the old woman, rocking the baby to keep him quiet, "it's not the end of the world."

Catena bowed her head. And the time it would take between the cure and the trip? And the others over there? That monster, Rosa, who had lured Mariano with a pipe dream, who'd put the thought of *La Mèrica* in his head in the first place? And before her eyes there appeared the lithe figure of her stepsister, the curvaceous body, tiny waist and full bust, the olive-colored face with red lips and haughty laugh.

As far as the cure was concerned, there was no time to waste. The next day as soon as Papà 'Ntoni had left for Baronia, *gna'* Vita covered her head with a shawl and put the child on her shoulders so she could accompany her daughter-in-law to the pharmacist, *don* Graziano.

They insisted on beginning the cure immediately, that very morning. The old man adjusted his glasses and had the young woman sit down, holding her forehead with one hand and with the other administering drops to her eyes of a solution he'd prepared.

"Only a few drops, he said," murmured Catena, biting her lip as the medicine streamed down her temples and ears.

"*Don* Graziano," repeated Mamma Vita a little louder, since the old man was half deaf, "just a few drops, just a few."

"Quiet," answered the pharmacist, taking offense. "If you don't have any faith in me, go find yourselves another doctor."

"Excuse us, sir," begged the young woman. "It's just that I read the prescription."

And she followed the old woman out, holding a handkerchief to her eyes because of the sharp burning that she felt there.

Morning after morning the two women went to *don*

Graziano's. After a week of that torture the mother-in-law asked: "But is the medicine really helping? To me it seems it's doing more harm than good."

"I've wanted to say something, too," sighed her daughter-in-law. "I've never had anything wrong with my eyes, and now they feel like someone's sticking a hundred pins in them."

What to do? Maybe the best thing was to stop the medication and get advice from another doctor. So Mamma Vita went alone to thank the pharmacist, bringing him a pair of red hens chosen from among the best in the chicken coop, and then she went with her daughter-in-law to *don* Pidduzzu Saitta, the oldest doctor in the village.

He observed Catena, who was looking at him dismayed, and then delicately lifted her aching eyelids just a little.

"Who treated your eyes?" he asked

"*Don* Graziano."

"The pharmacist?"

"Yes, sir."

"You poor peasants!" murmured the doctor. "And you want to travel to *La Mèrica*?"

"Yes, sir."

"Let's hope so. Come back tomorrow at nine. We'll try to cauterize them."

Catena followed her mother-in-law out with death in her heart, and as soon as she was home she threw her cape on the bed and with her face buried in the rolled mattresses began to cry uncontrollably, just as she had done on the night she'd returned from Palermo.

Mamma Vita, still standing with the sleeping child in her arms, didn't know what to say to calm those sobs.

"Listen," she then said resolutely. "Saitta is a bird of bad omen. He always sees things worse than they are. I wouldn't go back there. There's Panebianco, you know. He's the doctor for the poor!"

Catena raised her face, wet with tears, and looked at her mother-in-law with a ray of hope.

"We'll go after lunch," asserted the old woman. "Courage, my dear, do you think I don't understand you?"

And she looked at her with those small, clear, dark eyes so full of sadness because she loved her, loved her just like a daughter.

"Look what a rosebud he is," she said, bowing her head over the sleeping baby, "and how much he resembles him! And you, why all this crying?" she said, comforting her with a sigh. "You have your little one, and you'll see your husband again. I'm old, you know, and I've been separated from that son of mine, whom I'll never see again. And I always thought I'd have him with me, and I wove at the loom for his family. Now, it's over. Don't you see what's become of *ssù* 'Ntoni? How desolate the beautiful land of Baronia has become?"

In the afternoon, they went to Panebianco for one last try. Panebianco, fat as a sow, laughed the way he always did when someone brought him a gift; then he studied Catena's eyes for a long time, fingering her cheeks with his thick, light fingers.

"Ruined?" he continued repeating, with the air of a man

who has all the answers. "Ruined? We'll see about that! You'll be leaving by the end of the month."

Morning after morning with the baby in tow they would go to Panebianco's; and Mamma Vita always brought a basket of eggs and fruit, a sack of grain, a hen, or a pair of pigeons under her cape because Panebianco, the poor man's doctor, accepted any kind of payment.

But Catena's eyes went from bad to worse; and when she'd get up in the morning, she had to hold a handkerchief over them till they adjusted to the light. She couldn't take it any longer and began to lose faith, even in Panebianco, and insisted on changing doctors.

Toward the end of the month a letter arrived from Mariano. He was beginning to earn something; there were thirty-five of them, all from Mistretta, and they'd stayed together; even the women were employed. All bits of news that felt like slaps in the face to her. She read the letter over and over, full of anger. He seemed happy, and *gna'* Vita thought again of *gna'* Maria's bitter words when she'd said one day that sons, once over there, even forget about the mothers who gave birth to them.

Catena lost all hope of leaving, and she no longer believed any of the doctors: tricksters, thieves, all of them, good for nothing but sucking blood from the poor. Panebianco alone had cost them six hens and who knows how much fruit and how many eggs.

In *ssù* 'Ntoni's little house, the days passed full of melancholy. There were neither holidays nor processions for the two women, always chores and church on Sunday, praying at the

altar of Saint Lucy. *Ssù* 'Ntoni had found a laborer to help him work the land, since his wife could no longer accompany him. He talked less and less, his thoughts fixed on his son, beautiful and strong as an oak, who was now working for others.

The baby wasn't doing well either, growing poorly both because he was being nourished with bad milk and because instead of playing with the other little ones, he was simply passed from the arms of his grandmother to those of his mother, being all that was left to them of Mariano.

Catena had become somewhat of a recluse and even shunned her friends. In that small, olive-colored face, now gaunt as though a fire were consuming it from within, her eyes appeared much larger and much blacker because of the dark shadows that encircled them.

She didn't even like to work anymore, though she'd been the best worker in all of Amarelli. She spent her days huddled on the front doorstep while Mamma Vita spun or mended, listening to the chatter of the child, who had learned to say "papa." And both of them, without ever admitting it, kept their eyes on the corner where the postman usually appeared, jumping up if they saw him approaching their house.

But the letters came less frequently. And Catena didn't even unleash her anger on her mother-in-law anymore; too many thoughts churned through her head, making her temples pound as if she had a fever; she thought of *La Mèrica*, with its tall houses and dark streets; she thought about Mariano, young and strong, of the good earth of Baronia, and she saw again the beautiful and haughty figure of her stepsister.

The neighbor women were no longer able to engage her in the slightest conversation. But at times they would hear her voice sounding strange and sharp; they heard her talking to her toddler as though he could understand her, calling him by a string of bizarre nicknames in a frantic, strange voice.

"My treasured star, my noble knight.
My blond Saint George. My little bee.
Only you are left to me.
Call Papa, call him, for he is far away."

At first the little one laughed when his mother's nervous arms would lift him up, but then, suffocated by the impetuous caresses, he always ended up crying.

One morning, seeing *gna'* Maria pass, Catena asked if she might have two large baskets for grapes and prickly pears to send to Mariano.

"He likes prickly pears so much, and there aren't any over there. . . . Yes, I'm leaving with the baby," she said, opening her huge, black, frightened eyes widely.

"*Now* I know about traveling!"

And since *gna'* Maria just shook her head, Catena turned her back, vexed, and sat down again on the doorstep.

No letters came, and her eyes didn't get better. And even though they'd made three novenas and three candle offerings to Saint Lucy, the saint hadn't looked with favor on her.

By now there was no longer any hope of being cured. And Catena had become so ill tempered that poor Mamma

Vita, out of pity and affection, never contradicted her.

One morning, in fact it was Saint Michael's Day again, *gna'* Vita closed the front door because it was cold.

Her daughter-in-law, who knows why, had gone down to the stable and said to her mother-in-law when she came back in: "Go get me those baskets that *gna'* Maria promised me for the tomatoes and prickly pears."

"What are you talking about, Catena? This isn't tomato season!"

Catena threw the door open violently, holding the child by the hand.

"What are you doing? It's not summer anymore, the cold is coming in! How spiteful you've become, dear! Have you no heart left in your breast?"

Catena looked at her. In that olive-colored face all you could see were her eyes, with swollen, bruised lids, like two blotches.

She sat down on the doorstep, put the little one on her knees and, making him dance, began to tell him, first softly, then louder, then in that strange, shrill, ear-splitting voice:

> *"My treasured star, my little bee, my golden grain!*
> *Call Papa, call him, he is far away.*
> *My star, my noble knight. . . ."*

She gripped him tightly with her small, nervous hands, lifting him into the air, while the child struggled to free himself, crying.

Gna' Vita was frightened and tried to take him from her, but Catena held on with an iron grip, and the poor woman could do nothing.

The neighbor women all came running, alarmed by the shouts of the women and the cries of the child. Begging her, threatening her, they tore the child from her hands, running the risk of hurting him, while Catena repeated, laughing with her eyes wide open:

"My treasure! My star! Call him, call him. . . ."

They thought she would die from convulsions, the way her mother had. But then she regained her composure. And she never again raged the way she had that morning.

She didn't recognize her son, she didn't recognize her mother-in-law, but she bothered no one. She spent whole days huddled on the doorstep with her chin between her hands, never feeling the cold of the north wind. And if a neighbor approached her, she would explain, with a strange smile on that small, dark face, how she was waiting for the steamship from over there.

"You see?" she would point, "down there in the big, big sea, the steamship that smokes and whistles."

The baskets with the grapes and prickly pears were ready.

"I'm leaving tomorrow. I'm cured now," she added, touching her eyes with the palms of her open hands. "I'm cured. Do you see? I'm leaving tomorrow."

Dainty Shoes

Le scarpette

Vanni and Maredda loved one another, but they couldn't even talk about getting married because they were so poor. Neither had fathers; Maredda was a weaver, and Vanni worked in the shop of *mastro* Nitto, the shoemaker. Often he would say to his mother: "No matter how much we work, we're just like ants, we scratch and scrape and barely get by."

"And what's there to do about it, my son? Getting by is already something."

He and Maredda managed to see one another for a little while late in the afternoon when work was finished and on Sundays at the first mass in the main church. A quick glance or affectionate word was all he dared. And yet they'd found themselves alone a number of times in the moonlight under the Sinibbio arbor with no fear of being seen; but even then Vanni had done nothing but take her hand, telling her, "You big, ugly girl! I love you so much, I do!"

He'd felt Maredda's frozen hand tremble in his and knew that even if he had embraced her she wouldn't have protested, but he didn't dare. Still, when he was near her, all he thought about was kissing her, and often in *mastro* Nitto's shop he told himself he was an idiot, regretting that he hadn't done it. But then again, Vanni, who'd grown up attached to his mother's skirts like a girl, had these delicate mannerisms, and no one had any idea where he'd learned them.

Maredda herself had told him countless times when they argued, "It's true, you won't ever do anything worthwhile because you're nothing but a dreamer!"

He would get offended, but everyone said that about him, especially because he played the mandolin like no one else could and because he was the best young man in the neighborhood of Sinibbio.

"It's not true," he used to tell her, "that I don't think seriously about things. Me, the one who doesn't smoke cigars or drink a glass of wine unless I'm invited to! Just wait! It won't be long before I can talk to your mother without fear of being thrown out like a good-for-nothing. I've already started buying some things, you know."

In fact, he'd already seen to getting a copper pot and twelve plates, and he'd worked little by little on a pair of dainty shoes with bows of yellow silk that had made Maredda blush with delight when he'd shown them to her.

"You start small and work up to bigger things," Vanni said. "The time will come when I'll buy you gold and dresses and then! . . ."

And he would look deep into her eyes, and she'd get as red as a poppy.

But however hard he worked he couldn't get ahead. Every now and then, for supplies of grain and wood, he would have to go into the stash that he'd saved up, coin by coin, month by month. And so one winter when he wasn't able to put anything aside except four gold coins, he began to get discouraged. *Gna'* Nunzia, seeing him suffer so, followed him around trying to cheer him up.

"Good times and bad times don't last all of the time. . . . You'll see that this hardship will pass."

But Vanni never answered; and in the shop he worked with his head bowed as though he were thinking. One evening while *gna'* Nunzia was at the hearth cooking a head of cabbage, he said, "I'm going to *La Mèrica*."

The old woman gave a start, as if someone had struck her between the shoulders. Then she set the fan down.

"You heard right. I'm going. What am I doing here wasting the best years of my youth with *mastro* Nitto who's sucking the blood out of me? I'm leaving."

"But we're getting by. . . ." his mother said.

"And we're getting old."

He had Maredda on his mind, and *gna'* Nunzia, who knew it, didn't want to say too much because the girl was honest and hardworking.

They ate without saying anything else to each other; *gna'* Nunzia watched her son as though she were seeing him for the last time, and her eyes brimmed with tears. Since his mother

hadn't opposed him, Vanni now felt the real weight of his resolution.

He talked about it to Maredda like it was a done deed. Maredda wept desperately but calmed down as she listened to the young man's reassuring voice.

"What am I doing here? Over there . . . I won't stay more than a year. I'll earn enough so we can marry and I can start up a shop of my own. Over there, gold doesn't cost much so I'll bring you back earrings."

Maredda smiled between her tears, and Vanni looked at her, turning his cap over in his hands and moving his head as if to say, "I'm not just a nobody, you know!"

Anything but a nobody! He had so many plans in his head and would always say, "I'll show you off in front of the sea and all its fish, you big ugly girl. You'll live like a lady."

And to him it seemed that he was already rich, with a wife and a house and a shop of his own.

In the beginning, even he was stunned a bit by his decision. Then, little by little, he started getting used to the idea and made it the subject of every discussion, wanting to appear upbeat. When he started getting ready to leave he didn't want his mother crying.

"It's not like I'm going off to war! I bet you won't even recognize me when I get back. If nothing else, *mastro* Nitto will respect me."

He felt that now he'd become like one of the older men, and he walked proudly with Peppe Sciuto and Cola Spica who were married and who were also leaving for *La Mèrica*.

And he wanted to appear cheerful on the night of his departure, too. Peppe and Cola came to get him at around eight, and *gna'* Nunzia accompanied him as far as Cicè. With reddened eyes, Maredda appeared at the window to say good-bye, leaning forward with her head peeking out between a basil pot and a rose.

In the street they met other emigrants; they didn't know one another well, but they gathered together as though they'd been friends since birth. Everyone wanted to appear calm, but everyone was leaving home and a woman. Cola held his young son by the hand, and gesticulating, he lifted the little arm he held tightly in his callused hand, making waving motions that caused the child to raise his eyes, frightened. As he passed in front of his *quota* he knit his brow and shook his head and cursed the ungrateful land.

But Peppe Sciuto began to sing, and then everyone joined in. And the street was filled with a strong, melancholy song that seemed to come from a single voice, at times reaching a pitch that was dark and menacing, at times trembling like an inconsolable cry, at times hushed like a prayer.

Maredda waited for word of Vanni, and it seemed like a holiday whenever *gna'* Nunzia had some news for her.

After two months the mailman handed her a yellowed letter with a printed address, and she read anxiously, full of emotion.

Vanni said lots of loving things that filled her with happiness, but then her mother started grumbling. The letter had arrived on a bad day. The bread in the cupboard was finished,

and because there wasn't any money to buy grain, mother and daughter were reduced to buying bread in a shop like the poorest of the poor, like those who just barely get by. And so, *gna'* Liboria, who was in a bad mood for her own reasons, lashed out at the innocent letter and at her daughter who believed the empty words of that fool who, even if he did come back with a little money, would never look her in the face. She had noticed Cristoforo of Licata, a tree trimmer who made ten *lire* a week, hanging around their little street, and it pained her to see her daughter turning her back on him coldly or slamming the window shut in his face. She could have slapped her for that!

"I'm old," she'd often say, "and you're poor. What do you expect from life? You're not exactly a well-off lady who can afford to have her head in the clouds! Don't you see that the fool didn't even make you a formal offer?"

Maredda was mortified, but she thought of her Vanni. She would have liked to at least send him a word, but they weren't engaged, and it would have been too forward, worse than letting herself be kissed in public.

After that, there were no more letters. Spring came and summer passed, and she didn't hear anything more about Vanni. The neighbors said that *La Mèrica* doesn't let anyone return, that the best years of youth are eaten up in that unknown land, and that an emigrant never comes home unless he's got a hundred gold coins to build himself a house.

Maredda believed those disheartening words, and while weaving she sang to forget about the pain of Vanni:

"I saw three roses on a branch
I don't know which to choose
There is no day that turns to night
When I don't think of you."

But Vanni did return the next spring. With him, he had his little gray trunk that had seen its share of roads and strangers and railway smoke, too. He brought nothing back except thirty-five gold coins, a pittance in comparison to the sums he'd dreamed of and planned for under the Sinibbio arbor. But he couldn't take it any longer over there. . . .

He talked about this right away to his mother who'd come down to Rosario to meet him. *Gna'* Nunzia, with her cape around her shoulders, didn't know what to say; she looked him over from head to toe, that son of hers, and it seemed to her that he'd grown thin and that he'd been lost and that she'd found him again. Opening the door, she let him pass ahead, and she pointed to the little bed with the clean, coarse woolen blanket and the tablecloth spread on the storage chest to show him that she'd waited for him. And while he was still standing, Vanni said to her: "I didn't make much, but . . ."

"It doesn't matter, my son. As long as you've come back. I thought I would have to die without seeing you again."

"Only thirty-five *onze*. And God alone knows how much I suffered to save that."

"It doesn't matter, my son. There's work here now because last month *mastro* Nitto died."

"I've got nothing else," Vanni continued. "But I'll be happy

with a bit of bread here in my own *paese*. Damn *La Mèrica . . .* she's an old whore that leads you down a bad road with all her flattery. Honest people hardly get rich over there! But I have enough to buy a bit of gold and clothes and some leather so I can work.

"Eat, Vanuzzo," said *gna'* Nunzia, her face darkening, "and don't think about anything else for now."

"Why . . . ?" asked Vanni, looking at her suspiciously.

Gna' Nunzia sighed, and since Vanni narrowed his eyes and furrowed his brow, she touched his arm and said, "Vanni, Vanni! So you returned only for her? For your mother you wouldn't have come back?"

"What are you talking about!" said the young man, shrugging his shoulders. "So why did I leave then?"

"Vanni," said the old woman. "You're still a dreamer and nothing more. When the bird flies away, do you think the branch stays empty? The branch is fixed, and the bird moves on, and if one leaves another takes its place."

"I . . . as God as my witness, I . . ."

"Vanni, Vanni, what are you saying? Why are you cursing? What do you expect? Youth wants love, and women want a husband!"

Vanni stared at the ground, dark and surly, with his thumbs twitching restlessly in his pockets. *Gna'* Nunzia ladled out the soup, a little frightened.

"It's getting cold."

"I'll slit their throats," mumbled Vanni. "It's shameful! Not to wait a year and a half! And idiot that I am I ate dry

bread and slept on straw so I could make thirty-five *onze*, cent by cent. But who is he? Can you at least tell me that?"

"He's from Licata, a tree trimmer. He was an eligible young man, and Maredda's poor. She's to be pitied. The blood boiled in my veins, too, but then I forgave her. You have to understand how things are. . . ."

"Well, if I run into him, I'll have a few things to say. He's getting the scraps, it's pathetic! I had the best; a girl's first love is what counts, not the second. And I'll tell him that. And he'll leave her. And then I won't take her either!"

Gna' Nunzia ladled and let him speak. When he'd vented himself sufficiently, she spoke to him and managed to calm him down. What did he really want to do? By now, Maredda had practically ruined herself. She'd been reduced to the point that if the tree trimmer decided he didn't want her, she might as well tie a rock around her neck and throw herself into the sea. The mistake had been in not getting engaged. Wouldn't it be better now to let everyone go their own way and not get tangled up with those two dishonorable wretches?

She even persuaded him to eat. And after having eaten, he felt like a new person, so much so that the old woman remarked, "It was hunger and exhaustion, my son. You were seeing things with an ox's eyes. Happily, because you're young, there are still plenty of girls!"

"That much is true!" agreed Vanni. "This time, I'll let you find me a wife. As God is my witness, I want to get married by Saint Joseph's Day."

Later in the afternoon, friends and relatives came to

celebrate Vanni's return. He was all animated now, feeling like a man who'd experienced life, and he spit on the ground while talking about *La Mèrica*.

Toward evening when everyone had gone, Vanni went looking in the chest for a clean shirt, one of his old ones. With his hands he touched something hard—the cardboard box that held Maredda's dainty shoes.

"Women's things! . . ." he muttered, his face darkening, and he flung the box far into a corner.

"No, no," protested *gna'* Nunzia running to pick it up. "If, let's just say, *another . . . your bride*, is the same size? Wouldn't it be a shame to spend more money? And besides," she added, blowing delicately on one of the bows that had bent slightly, "they're brand new!"

Vanni closed the chest, nodding his head in a sign of approval.

Grandmother Lidda

❦

Nonna Lidda

God, it seemed, wanted to test Grandmother Lidda with all the misfortunes he had sent her. She was a widow and poor; her daughter-in-law had died, and her son had nothing but *La Mèrica* in his head. Out of all this sadness only Nenè was left to her. Her daughter-in-law, God rest her soul, was barely able to nurse him, so that the evening Grandmother Lidda had to take him home with her was truly frightening. No one had thought about milk in all the sad confusion, and she got him through the night with a nipple soaked in water, her heart breaking the whole time at the sound of that little creature crying from hunger.

Then, after just a short time, her son had run off to *La Mèrica*.

"I'm leaving him with you," he said. "Raise my son like you raised me."

Over there without a mother, that little thing, God love

him, would have surely died. And the worry of caring for the child left the old woman no time to weep for her son, who was leaving. She wasn't even able to accompany him to Santo Stefano, and she barely followed him as far as Rosario—she only saw him turn the corner along with the other young men and said good-bye to him waving her hand from afar as long as she could still see him, because he turned three times with a smile on his lips and a pale face. And then immediately she headed home, bent over in her black shawl to get back to the little one she'd left in the cradle. Anything but time for weeping with that little creature, who was hungry one minute, then crying uncontrollably the next for no reason, and then suddenly quiet again! *Gna'* Lidda felt an overwhelming tenderness when she climbed into bed with that tiny one next to her; and at certain times during the night she would awake with a sudden fear that she might suffocate him in her sleep. It truly seemed as though time had turned back to when she was young and had her own little boy sleeping next to her. What a happy time that was! And she would sigh heavily, her heart so full of sadness that it seemed it would break.

That little one was a continual worry. She had to wean him early because she wasn't able to buy enough milk every day to nourish him properly, and so she got him used to a mixture made of very fine grain. She bathed him every day, just like the son of a gentleman, and changed his clothes often, since washing them cost her nothing—that was her job.

It was painful to see *gna'* Lidda at that age going to Buscardo with a basket of laundry on her head and the child in her

arms. She would take the laundry of the well-to-do and bring it back, always with Nenè in her arms. And Nenè would sometimes get a lump of sugar or a handful of rice for the broth, or some of the rich children's used clothing. Because if *gna'* Lidda was poor, God was great; and in this world there is no reason to despair, and the poor woman who contents herself with little will find food and assistance without knowing where and how, just like the sparrows and starlings.

Every month when the letter from *La Mèrica* would arrive, *gna'* Lidda would have *don* Cesarino's cook, *mastro* Nitto, who was a good man, read it to her. And she would have *mastro* Nitto himself immediately write her reply. Her son sent good news about himself, he was beginning to earn well, and soon he would send something, but at the moment he couldn't; he asked for news about Nenè and sent regards to his friends. Always the same letters and the same replies. But *gna'* Lidda waited with a sense of great urgency, and if the postman was a day late, she would despair. While the cook wrote her responses, she would watch him with her small green eyes, watch his hand and his delicate pen that transcribed the words she dictated. But was *mastro* Nitto really writing down exactly what she was saying? No. One day he had told her:

"You don't write the way you talk! People still understand."

From that moment on, *gna'* Lidda no longer had any peace. And when she would say, ". . . and don't worry about me, I'm poor, but I get by. Nenè is fine and growing. I bless you, my son!" she would crane her brown, wrinkled neck,

pursing her lips as though she wanted to infuse the page with her thought. And each time she would add, "Did you write exactly, 'I bless you'?"

Poor dear son! With all her heart your mother, who is so far away, blesses you!

And she would stay there watching until the cook closed the yellow envelope with the printed address—her son would always send it to her—and mailing it she always had the doubt that he hadn't written exactly what she'd told him to write.

Nenè grew slowly and was rather pale, "like all children without their mothers," *gna'* Lidda would say sorrowfully. And little by little he began to toddle, down a short stretch of road, with his grandmother close behind who watched carefully, and as soon as she saw him beginning to tire she would bend down and with an outstretched arm swoop him onto her shoulders. And Nenè, so as not to weigh her down—he already understood quite a bit—would wrap his arms around her neck. As he grew, he was even able to walk the entire way to Buscardo. And it was only then that *gna'* Lidda began to breathe a bit easier. Fewer responsibilities, fewer worries. They would get up early, close the door behind them, and with a loaf of bread along with two heads of lettuce in their basket they could get by till evening. At supper, *gna'* Lidda made the little one, whose health was delicate, eat an egg or a bit of *pastina* so as not to let him go to bed on an empty stomach. She herself ate soup only on Sundays, though at times during the night she felt weak from hunger.

In a letter, her son informed her that he had married a

woman from Patti who worked in *La Mèrica* as a presser. *Gna'* Lidda wasn't at all pleased by the news; now with a new family, he would no longer think about the old woman. Patience. At least the little one was still with her and once grown would be there to look after her. And sighing, she dictated to the cook: " . . . and bless your new wife as well. But do not forget about your mother, who is poor."

What was done was done, and it was pointless to torment him with reproaches. Returning home, she called to Nenè with more than her usual tenderness. He was all that was left to her. Her daughter-in-law was dead; her son in *La Mèrica*, no hope of ever seeing him again. . . .

Who knows if this time he might send her something now that she had practically asked him for it!? And she waited with more urgency than usual for the end of the month, it was the month of the dead, for his reply. Christmas was coming. In five Christmases he had never sent a thing. But this time, what if? He had married and said he was earning well. And while she washed, she repeated to Nenè, who was crouched on a large rock playing with stones from the river bed: "We're going to have a big celebration at Christmas. Papa is going to send you something nice."

And she hadn't deceived herself. On the last day of November a letter arrived, and in the letter were three large bills the likes of which *gna'* Lidda had never touched in her life. Should she tell *mastro* Nitto now, to make him envious and to ward off evil spirits? She regretted more than ever not knowing how to read, but she had to tell him. She listened

with a pounding heart as he read the letter. It was longer and more affectionate than usual. But little by little as the cook read, in the same voice as always, *gna'* Lidda's lips pursed and lost their color. Suddenly, she leaned against the wall, because it seemed the house was spinning around her. And since the cook had finished, she begged him with a weak voice: "Read it again, *mastro* Nitto, there must be a mistake."

No, there was no mistake. He'd read it correctly. And the same *mastro* Nitto, who never showed any emotion, slowly folded the sheet, put it back in the envelope, and looked with pity at the old woman while stroking his short curly beard.

"And now?" said *gna'* Lidda slowly in a voice that hardly seemed her own.

Mastro Nitto slowly shrugged his shoulders, shook his head, and said: "He's his son. There's nothing you can do. . . ."

But just like that, all at once? And without even a month's notice? Maybe *compare* Tano was traveling; maybe he was already in town. And couldn't he have come along with *compare* Tano to see his mother as well? He was asking for the child just like that, as though it were nothing. Forgetting that it was she who had raised him with so much difficulty, an old woman, when he had left him to her just like you leave a kitten! Didn't he know what a blow he had dealt her, oh estranged son! Oh wretched son!

And the old woman fell silent, and while looking at *mastro* Nitto with her small, dry eyes, so many disconcerting thoughts whirled about in her mind. Getting up and taking the letter she only murmured: "May God's will be done. If only I could cry."

But she could not. It was as if her dry throat was bound by a cord.

Compare Tano was in town. He was spending Christmas with his relatives, and he wanted to leave immediately after. The old woman passed Christmas Day with a heavy heart, yet she made an effort, wanting to make it a cheerful one at least for the child. At mealtime she gave him chicken soup and sweets. She herself could not touch food, but she felt full just seeing Nenè eat with so much joy. She washed his entire wardrobe, mended wherever there was a tear, attached buttons where they were missing, and then chose his best clothing, and made him a little bundle. There were his little flannel shirts, new shoes, and little dress suit—the first he had ever owned and that had cost her three loads of laundry. . . .

In the bundle she also placed the dress of Our Lady of Grace, for they said that over there people were without religion, and last of all she added a Christmas whistle so that the child would remember his grandmother so far away. Poor child, who could tell if they would take care of him the way she had. Then, she waited for *compare* Tano to come and get him. He came on the evening of Saint Stephen, a night that was gray as lead, appearing at the door, bundled up in his black cape with his cloth hat pulled down over his eyes. "Is he ready, *comare* Lidda?"

Gna' Lidda handed him the bundle without speaking. She was afraid to open her mouth for fear the words would come tumbling out unchecked. Then she took the child in her arms. "Keep him covered well." She reached for her new colored

shawl that she had never worn and wrapped the child in it so that all that remained showing was his little red face and two lively black eyes, like those of a baby sparrow.

She kissed him on his tiny cheeks, with strong kisses that tasted of tears. But she did not cry. She placed him in the arms of *compare* Tano, who took him gently because he understood the grandmother's suffering. Only when she saw the man turn, with the bundle beneath his arm and the child in his cape, did she shout, "*Compare* Tano, I am entrusting him to you! . . ."

And she remained there looking on with bony hands in her gray hair, disheveled by the north wind.

For two days she wandered around the empty room without crying, not knowing what to do, praying that God, who had taken everything from her, might now also take her miserable useless life. Then on the third day she took her basket and headed out toward Buscardo. She kept her gaze downward, and it seemed as though she felt Nenè's little hand in her own. He would still be traveling, and it was so cold. But she had given him her shawl, thank goodness.

A woman looked at her and said to Nino the cart driver, who was passing by, "*Gna'* Lidda seems disoriented today. She's walking like a body without a soul."

A wind was blowing that cut to the bone. Buscardo was completely gray, and the water was frozen. There was no one washing because everyone had been frightened off by the cold. But *gna'* Lidda felt nothing. With a rock she broke the frozen water and began to do the wash. Her hands grew numb, and

she didn't feel it. She stayed there bent over the smooth rock, without washing the wet clothing.

She thought: now she no longer needed to work, now that the little one was on the steamship, in her new shawl. Who knew if *compare* Tano was looking after him properly. . . . She had not reminded him about that. . . .

Toward evening Nino was returning in his cart with his head wrapped in a shawl, whipping his mule so he wouldn't freeze. Passing by Buscardo, he happened to look toward the shore where he saw something that looked like a human lying there. Shocked and curious, he went to take a closer look, making the sign of the cross as he recognized the figure of *gna'* Lidda, face down and stiff on the smooth rock.

America 1918

❦

La Mèrica

Whether that Petrù was ever coming back was something Venera hadn't thought about for quite some time. On Saint Michael's Day it had been eight years, and eight years is a long time. When summer passes and winter passes, Christmas passes, and then another comes, you even forget about the dead.

Before . . . oh! Before, she thought she'd die because of it. She'd wept, railed, gone without eating for days on end, as though mourning someone in the house. Poor and abandoned, she'd expected nothing but sickness and death. Instead, she'd taken ill but didn't die. Spring found her with fevers and the sun inviting her to sit out on the doorstep.

A life of hardship! Petrù wrote once a month, each time sending her a few *lire*. He'd left with the idea of becoming rich and, without ever mentioning his return, ended every letter with the same words: "I'm fine and hope you are, too. Am

working like an animal, thinking always of home, and there are moments when I wish I had wings to come back."

"Wings!" repeated Venera, annoyed. "Does it really take wings? Does he forget that his wife is wasting the best of her youth waiting for him? Or doesn't he know that a woman can't support herself on twenty-five *lire* a month?"

Every letter gave rise to outbursts with Brasi, the cobbler, who lived in the house next to hers. She would spin, he would pound leather; she would sigh, he would comfort her. And yet it did her good to know that at least one of God's creatures was aware of her worries. In the evening, too, when the little street was empty and the yellow lamplight flickered on the rough cobblestones and dark houses, Brasi would come to sit beside Venera on the step. He always brought his dinner: a piece of bread, a little cheese, or a head of garlic.

"Take some!" he'd say, breaking the bread.

"Thank you, *mastro* Brasi, but I've already eaten."

"What are you talking about! Your lips are white!"

"It's that I can't pay you back, *mastro* Brasi," said Venera, biting hungrily into the bread. "My house, you know . . . you could rummage through the whole thing with one sweep of the broom. There's nothing but poverty in every corner!"

And they would have supper together, almost happy, though they felt themselves to be the poorest and most abandoned ones on the street, with every other door closed and every family gathered round a steaming pot. Sometimes the light would flash on the rough cobblestones, and sometimes it stayed in the streetlamp like it had been gathered up and made smaller.

Only the stars could see them from the dark sky high above.

Venera went to confession often, always trying to persuade the priest to give her absolution as she trembled behind the grate. "Oh Father! I'm like a reed buffeted by the wind, like a hermit in the middle of temptations. . . ."

And Father Olivaro, who was old and saintly, would reproach her severely, but then, seeing that she was sorry, would give her absolution. And Venera left with her soul relieved.

But little by little she stopped going to confession, and whenever she would meet Father Olivaro she'd wrap herself up in her cape so she wouldn't have to say hello to him. And she no longer got so worked up when she received letters. She just accepted it. Time passed, and it passed; and there were moments when she even forgot she had a husband in *La Mèrica*. If the neighbor women would ask, "Oh! Venera! And your husband?"

"He'll come back when God wants. . . ." she'd reply. But it was only her lips that said it.

It seemed like she and Brasi were husband and wife. Brasi would give her what little money he had and tell her: "Find me some soup. Day-old bread isn't going to do it for me this evening."

And when the neighbor women shut their doors, Brasi would go into Venera's house. She was terrified of him. She served him as though he were her master, never even buying a skein of hemp without first asking his permission. Sometimes he beat her, but she didn't fight back; she didn't even miss her husband in those ugly moments. Brasi or Petrù, it was all the same. Petrù, who was always in a dark and violent mood, had

beaten her like an animal in their two years of marriage. Brasi at least, even if he was rather sickly and moody, had his good days, and if he came across a bit of money, he'd buy wine and pasta, saying: "Let's live it up a bit just to spite your husband."

Husband! Eight years are eight years. She hardly ever thought anymore that he might be coming back.

And so when the letter came at the end of the month saying, "As I'm sending this letter off, I'm leaving," Venera felt the earth give way beneath her feet.

"Scoundrel! He could be here tomorrow, even this evening. Suddenly, just like that . . . as though the house were an inn, always open."

Did he think he was going to find a celebration in the house? You don't just leave a woman for years and years alone with no means of support.

But little by little she settled down. A husband is the head of the house. She was his, and he could throw her out, just like that.

Her husband! She remembered him, strong, well-built, violent. . . . She was afraid of him now just the same as if she'd seen a living person rise up from an open tomb, a living being angry and threatening.

But if he'd gotten rich?

She went to confession. She felt the need to be calmed and pardoned. And Father Olivaro, raising his trembling hand behind the grate, absolved her: "It is God who pardons you, God who sees you, miserable creature made of mud."

And Venera left there with her soul relieved. She set out

the few household furnishings and cleaned the house as though it were Easter. A new life was beginning. Terrified, she warned Brasi: "For the love of God, Brasi. . . . It has to be like we never met! A man like that . . ."

And she shivered. But once she rolled up her sleeves to wash the hearth she felt tranquil and at peace again because she'd fulfilled all her duties and was beginning her new life as a married woman, the same as if she'd done nothing but waited for her husband. But she also thought: "He could come back rich. Rich, yes. . . . And then I'll have no reason to envy *massaro* Nitto's wife."

Petrù arrived in the evening with three large suitcases, wearing a cloth overcoat and felt hat, just like a gentleman. He was the same only much more pale, almost angry, like a living person coming out of a tomb. As for the rest, he hadn't changed. It was him, with his broad, squared-off shoulders, one slightly lower than the other, and his slow walk.

When he came in he embraced his wife, then threw his hat on the bed just like he'd used to toss his cap.

"So, Venera?" he exclaimed looking around.

The terrified woman couldn't unknot her tongue. She felt she was dreaming. It seemed that eight years were only eight days and that her husband had never left home. He walked around the room with a sleepy look, as though he were looking for something, as though he didn't feel he was in his own house.

"Do you want something to eat?" Venera finally asked.

"Yes, I'm hungry."

Venera knelt down in front of the clean fireplace. She lit the fire and blew forcefully, getting red up to her eyes from the heat and emotion. One moment it seemed that her husband had always been there, at that hour, waiting for his dinner; the next she was trying to make sense that he'd even returned and that from here on out she would have to live together with him. Petrù tasted the soup, then pushed the plate away.

"Don't you like it? Oh . . . that's right, now that you've become a gentleman . . ."

"I haven't become a gentleman. I'm sick," responded Petrù.

Venera stared back at him. There was a streak of gray in his thick hair.

"At least . . . at least you made your fortune?" she ventured.

"Fortune!"

"You were gone for so long! You would have been better off coming home sooner."

"That much is true. Better than coming back now, old, poor, and sick."

Venera heard only one word, and she repeated it, taken aback.

"Poor?"

"Poor, absolutely, like the worst of beggars." He followed his own intimate reasoning that Venera couldn't grasp. Looking at her coldly, he said: "Don't make such a face. We'll have enough to get by."

They didn't say anything else because they had nothing more to say to one another. What had gone on in the past and

what each of them carried in their hearts like a weight, no, that they could never confess. And they hadn't yet had time to find something in common that might unite their lives.

Venera washed the dishes in a corner by the fireplace. While her husband got into bed, she lined up the small chairs against the wall. Then she walked around the room for awhile, unsure of what to do, and finally began to undress slowly.

Petrù had seemed the same when he first arrived, but he was another person. He was still a handsome man, tall and robust, but now his one higher shoulder was bent, and his cheeks were gaunt. And a wrinkle carved in the middle of his forehead gave his eyes an expression of fierceness and pain that wasn't there before. He now stayed silent for long periods of time as though preoccupied by a fixed thought, and he observed everyone and everything with suspicion. At times he would stand just gazing about with the distracted air of someone who appears to be looking for something and then suddenly forgets what it is.

A few weeks after his return, he stretched out on the bed board and announced to his wife: "I've rented out *don* Ferdinando's store."

"To do what?"

"I want to open up a grocery."

Suddenly, Venera cheered up considerably, and from that moment on she showered her husband with all kinds of attention and consideration. But he just lowered his head, remembering that first evening when his wife had repeated: "Poor?" with that stunned look on her face.

The grocery store took off quickly, with all kinds of things coming in from *il Continente*. And rather than pay an outsider, Petrù taught his wife how to keep the books, how to weigh, and how to slice. As people crowded around the counter, husband and wife took in money by the ton because in their store you could find fresh, quality products the likes of which had never been seen in *don* Calogero's shop.

But Petrù wasn't happy. One day he said: "Venera, success has come, but my health is gone."

It was the truth. He ate little and suffered constant stomach pain.

"Over there your body doesn't realize it, but in the peace of the village you feel the effects," he continued. "In *La Mèrica* they ruin us. No one can escape it. It's like droplets of water that corrode a rock."

He asked himself why he'd worked; who he'd come back for. . . . He was as alone here in his town as he'd been in the huge American city. He suffered a burning, unquenchable thirst.

"I feel like my stomach's in shreds," he'd complain. "All I did was work a clothes press, six hours a day, pressing pleats, nothing else. An iron so heavy it ripped my stomach in two." He called the doctor, who was puzzled. "It's a new illness!" he repeated, observing Petrù.

The doctor prescribed cool liquids and just to be sure put him on a diet of broth and milk. Petrù followed his instructions faithfully. He even stopped going to the shop because the smell of fresh cheeses brought on a feeling of weakness, a violent and

irresistible desire to eat that would then make him cry like a baby. And he wanted to get better. But he got worse.

He would spend whole days seated on the bed with his hat thrown back on his head and his restless gaze fixed on the door. If friends stopped by to keep him company, he heard their conversations without ever listening to them. Whenever he changed positions he would sigh heavily or bite his lip in pain.

And he became silent. If he did speak, he retold the story of his trip to *La Mèrica*, using the same words. "I went there," he always concluded, "so I could open a grocery store."

And he never added anything that might help explain what he was thinking. What he wanted to say was that he'd wasted his life for nothing. With his eyes on the door, he seemed to be waiting restlessly for someone who never showed.

He knew death would come, today or tomorrow. And he was afraid of death.

Venera would put the pot of broth on the fire and then go out. At noon, when the store closed, she busied herself for a few hours tending to her husband

"Do you want soup? Milk? Do you want me to plump up the mattresses? Do you want to put on a wool sweater?"

He didn't want anything. He sipped his broth and forced liquids down, overcoming his nausea with the pained hope of getting better. He now answered his wife's questions only with gestures, but gradually he came to enjoy her attentions and would say to his friends: "A man without a wife isn't a man. Only a wife takes care of us and looks after us the way no other woman can."

Venera ran the store better than a man. The daily handling of money, the constant reaching for Swiss cheese and *mortadella*, had given her a new purpose. Having put on some weight and now dressed in the finest wool and always cheerful, she was a consolation to see.

And since Petrù had abandoned the store, Brasi no longer worked as a cobbler and instead just hung around the doorway, yawning between jars of preserves and a barrel of dried herring. He was waiting to become boss of the shop so he, too, could get behind the counter and wear a nice cloth apron.

Venera wasn't in a hurry, however. As things stood, she felt like a queen. With her husband sick and in need of medical attention, she was free to do what she wanted. And Brasi, not wanting to be cast aside, now treated her like a lady. If a poor relative stopped by to ask, "How's Petrù doing?" Venera would respond rudely. "Better. He's better!"

And then, turning to the vendors with her knife raised above the *prosciutto*, she would add: "Vultures! They're all vultures! As if the poor man hasn't earned his money."

Needy relatives were the only thing that worried her. Petrù had brothers and nephews who were dying of hunger, and in a moment of weakness he could write who knows what kind of nonsense into his will.

But had Petrù made a will? No one could understand that man. What was he thinking? What did he want to do?

"He's making me crazy," said Venera. "It's like he lives in another world."

Was he tormented by some regret? Was he hoping to get

better or had he resigned himself? Uncommunicative, taciturn, and consumed by suffering, he was plagued by one fixed and painful thought. And he spoke simple words, sometimes even nonsense, with a sigh that made his broad chest heave. Often he would repeat: "I came back to start up a grocery."

But he wasn't saying it to his wife, or to his friends, but to an invisible someone that only he could see, terrified, there at the closed door.

I Take You Out

Ti-nesciu

In his day, the lawyer Scialabba had been the best in town, so much so that they referred to him simply as "the lawyer." But since his wife had died and Nina Bellocchio had dumped him like a dog after having taken him for everything, even his vineyard, his luck started running out, too. Every now and then he still accepted a small case or two, and when he did he felt reassured and would prepare pompous speeches. But when he arrived in court, between his younger colleagues who poked fun at him and the judges who knit their brow to keep from laughing at him, well, he lost his train of thought, a train of thought too feeble for ideas that were too weighty, and he would start in on subjects that had no conclusions, mixing in outdated expressions that had been heard a hundred times before, while the lawyer Millone sketched his caricature on the cover of the law code. And yet he showed up like clockwork in court, all spruced up with his frayed but sparkling white

collar and clean-shaven, sunken cheeks: it was a habit he couldn't break, like that other one he had of always speaking Italian with his daughter and the peasants.

In the winter, which for him began in October, he donned a greenish overcoat, and when he felt like summer had returned he would go back to wearing his famous iron gray trousers, long and tight fitting along the instep, and a black jacket cleaned each season with the help of a little benzene solvent. Only his daughter was left to him in his sad and pitiful old age. She'd resigned herself to keeping him company; and to provide her with some way of passing the time he'd take her out walking every evening along the main street. They would go up as far as the Châlet, and there, seated on a bench, in the wind or the dampness or the moonlight, they would stay awhile, silent, still, and sad, until the park was deserted.

Since Liboria was always dressed so plainly, she preferred going out in the evenings when the light from the streetlamps wasn't so bright. Yet even then the richest girls in town found a way to make fun of her, pointing out the black feather she put on her hats, sometimes placed straight, other times to the right or to the left, in summer and winter alike, or the ribbon that served as a bow one day and a belt the next. But Liboria walked impassively with her feather and her bow, lowering her eyes and turning pale only when the Saitta girls or the *baronessa* Caramagna passed her since they always wore hats that seemed to fill the entire street.

She went out walking every evening, driven by the same unspoken and timid hope of finding . . . good Lord, she herself

didn't know what or who it was she wanted to find. When she thought about it, she would get all upset and call what she was waiting for so vaguely her "fate," her "future." Who knows if someone from town, or even an outsider, seeing her so serene and unpretentious, might not think of settling down? It wasn't exactly easy, she knew that well, since these days no one can marry with nothing, but—she implied blushing to *gna'* Filippa and *gna'* Ntonia, who on those long afternoons would come up to the house with some excuse, lean against the doorway, and start up that same never-ending conversation—she would say, they needed to understand that a girl who knows how to run a house, who is thrifty and clean, has her dowry in hand. What good are those little butterflies who have twenty, even thirty, thousand *lire* and throw fifty out the window? And she timidly made note of her own case, without ever complaining about her father, while the women praised her with grand gestures that ended up raising her hopes. If not for them! *Gna'* Filippa always had her eye out for a good match, and Liboria went without her glass of wine and ate less at meals so she would have something to give them.

But over time, little by little, *gna'* Filippa's imaginary matches began to vanish; the hat feather continued to fade, and the lawyer's earnings grew increasingly uncertain. Father and daughter, however, still went out in the evenings at dusk, always a bit sadder; and Liboria, seated on the bench in the Châlet's half-deserted park, felt a great weight in her heart like a cry that was trapped. And in the darkness, the broad, shadowy treetops that rustled lightly above seemed to murmur sad

things. Coming down the poorly lit street so late at night, she felt more piercingly than ever the shame of those walks. The bitterness of so many years, of her lost youth, turned rancorous, and once home she would begin to take it out on her father.

"Do you understand what a miserable creature I am? That there's nothing left for me except to throw myself in the sea?!"

"What can I do for you," mumbled the old man, his voice trembling. "*Ti nesciu, ti nesciu*, I take you out, I take you out every night! Is it my fault?"

And he would sigh, forgetting to speak in Italian. They overheard him one evening, and in town they started calling him *Ti-nesciu*.

He no longer went so regularly to court; they were now starting to laugh in his face. Only rarely did he defend a case and he did so with few words, spoken slowly and in a wavering voice, staring anxiously at the judges and his younger colleagues with his small, clear eyes that were partially veiled by swollen eyelids. He did manage to bring home a few *lire* that he handed over meekly to his daughter, but only after taking a few coins so he could go play the lotto. An old, long-shot dream of his.

And they no longer had hot soup every night at dinner; early in the morning, *Ti-nesciu* would timidly enter *donna* Mariannina's shop to buy a two-cent loaf of bread, explaining in a halting voice, as though he were making excuses: "You know we eat so little . . . it's just the two of us, my daughter and me. We no longer have maids in the house. It's just us . . . two people! . . ."

And he repeated the same barely coherent words, pushing past the women who crowded around the counter and placing the loaf carefully in the pocket of his overcoat that he now also wore in the summer, in part because of the terrible cold he always felt, in part to hide his suit.

One morning the baker wrapped up two loaves instead of one without saying anything, and the lawyer, who only had two coins in his pocket, reddened.

"I just asked for one. You know, we eat so little—it would only be left over."

"Excuse me for taking the liberty, sir. Take it to the miss. It's fresh . . . still hot, see?"

He blushed even more, nearly turning purple, but he lowered his eyes and said his thanks, tottering out painfully on his thin legs and feeling worse than if someone had slapped him.

Liboria eventually started pulling out the fine lingerie and linen her mother had left her that was supposed to be part of her dowry. *Gna'* Filippa would slip out with the delicate undergarments and beautiful sheets hidden under her shawl, coming back with a few coins that she handed over with loud sighs.

"You wouldn't believe, miss, how long I walked around. Since it's about buying, no one thinks it's good enough."

"I'm warning you, *gna'* Filippa! Don't mention my name! I'd die of shame."

One day, after the last pair of embroidered sheets had been sold, she made herself a red dress. It looked bad to go out always dressed in the same thing; it made her seem older, clumsier, poorer, and yet it was necessary to be seen. And with

her new dress and her feathered black hat, she now went out even in the daytime, arm in arm with her father, who was more hunched over and smaller than ever in his old green overcoat. And as she walked, she did her best to keep her shoulders straight even when they seemed to curve involuntarily, her eyes wide and restless in a face that was pale and sagging, and a mouth that wanted to affect a happy expression, when all the while the strangest and most melancholy thoughts swirled about in her head.

But once back home, as soon as she reached the stairs, she would let go, and her face took on the usual bitter expression as she vented herself on her father in a voice that choked back tears.

"Is it my fault?" he would answer her. "*Ti nesciu*, I take you out!"

And you could always see them out on the street and behind all the processions at the very end, among the wave of black shawls and heavy overcoats, the red dress of the lawyer's daughter standing out, as *don* Pepe said, like a stick of sealing wax. And without fail, you could see them again in the evenings, sitting silent and still on the Châlet bench in the half-deserted park, where the trees rustled lightly and seemed to murmur sad things.

Her Father's House

❧

Casa paterna

When she got off the boat, Vanna found her father and two brothers Antonio and Nenè waiting.

While Antonio tended to the bags, her father closed his hands around hers just as he'd done when she was a child, and asked: "Why are you alone? Why did you leave so suddenly?"

"I'll explain later, Papa," answered Vanna, blushing.

When they were all in the carriage, Antonio said: "If you'd let us know sooner, someone would've found a way to. . . . What were you thinking, coming by yourself?"

It was her father's turn to respond: "She'll tell us about it later."

So they all kept quiet, a little embarrassed.

"Is everyone well at home?" Vanna asked after awhile.

"Great. Mama especially wanted to come, but then it wasn't possible. The whole caravan wanted to come with her," remarked Antonio.

"You're going to see some new faces," added Nenè.

"That's right, Viola and Remigia. You wrote to me saying you're all living together now."

"Almost together. We bought the apartment attached to our house. It seems to me we wrote you about it."

"No, I don't know anything."

"No?! But I'm sure. . . . Well, we bought it. It has eleven rooms: five for Luigi and six for Nenè, the moneymakers of the house. I'm with Papa. Each family lives separately doing what they want, but we take our meals together. Everyone gives a little money each month to Viola, who manages everything."

"So you're all boarders now?"

"Yes, except that we've stayed together as a family," explained Nenè, raising his voice because the noise of the wheels against the gravel drowned out his words. "It's convenient, you know. It costs you half."

"Is that right?" said Vanna, distractedly. And they fell silent again.

Vanna was looking at the road that ran alongside the sea, the crescent-shaped port that was quickly disappearing, the sleepy market with its collapsing tents and overturned stalls; she recognized a few flowered terraces, the point on the beach where she once used to swim. In her discouraged face, in her sweet eyes full of sadness, a light passed that seemed feverish. She was impatient to arrive; restless and on the verge of tears, she gave a start every time the carriage hit a bump.

You could already see the pink wall with the green

shutters, the terrace with its arbor of yellow roses. The coachman whipped the air happily, and the horses slowed their trot.

Maria, her mother, and Ninetta were at the door. Her two sisters-in-law, the new faces, introduced themselves in the dining room. Vanna had not yet met them. They were both tall and sturdy, Viola very blond and Remigia dark haired, beautiful young women with full breasts and pale complexions that made her feel immediately ill at ease because she was dark and slender.

Her mother and Maria smothered her with kisses. They looked at her and spoke to her with obvious concern. It pained them to see her so dejected, so changed after three long years; they were almost afraid to question her, fearing she would only have sad things to tell them.

Taking special care, her mother accompanied her to the "cat's room" an immense space that had always been empty and that they called the cat's room because a tabby, who died of old age, always went in there to sleep on the windowsill.

When Vanna was a little girl each room had its own name. Any random fact that might be repeated or that incited the children's imagination gave rise to a new and bizarre name. And so there was the "prickly pear" room, the "book" room, the "pink" room.

"We prepared this one for you because yesterday, with such short notice, it was the best we could do," explained her mother.

"I'll be fine here!" said Vanna. Unpinning her veil, she looked at her mother. It seemed she was only now really seeing

her, face to face, and her heart ached. She found her so much smaller, almost more humbled.

"And mine?" she asked, placing her veil on the bed.

"Yours?"

"The pink one, where I was before."

"Oh! Ninetta sleeps there now. What can you do . . . now that there are so many of us, the rooms are all taken. And besides, like I told you, we hadn't even hoped to see you this year. . . ."

"But even when you came with Guido the first time," interrupted Antonio, who had appeared, "we fixed this one up for you."

"Of course," replied Vanna. She was confused because she wanted to say that *this time* she wanted to stay forever, and she felt that no one was really happy about such an idea.

But her mother began again in a voice that was sweet and weary: "I never thought I would have to see you *like this* . . . after three years. Did something happen, Vannicchia?" Fighting back tears, her lips trembled as she pronounced those words.

Vanna blushed deeply. "All right," she answered quickly, "I quarreled with him, badly."

Her brother knit his brow. Her mother set the candle on the nightstand.

"And . . ."

"I couldn't take it any more. Why are you making that face, Antonio? Didn't any of you want me back?"

"That's got nothing to do with it! It's that you've put us all in a bad situation. Your husband might think that we've . . ."

"No, no. It would never cross his mind that I'd come all the way down here."

"Aren't you clever! And what do you think he supposes then? You're always the same Vanna, trying to convince yourself of things," said Antonio, smiling so as not to reveal his true feelings. "What did Guido ever do to you? You'll see," he added with an air of indulgence. "I'll write to him, and everything will be fine."

"No!" cried Vanna, as if someone had wounded her. "I won't allow it! I'd rather throw myself in the sea!"

Vanna's mother made a sign for her son to be quiet. Didn't he see that Vanna was so tired and agitated she couldn't reason? Why torment her?

"Tomorrow," she repeated. "Tomorrow when she's more rested . . ."

Left alone, Vanna looked out. She wasn't sleepy. From the window she tried to imagine what the sea was doing. She always used to amuse herself guessing about the sea at night.

She sensed the gravity of the step she had taken but didn't regret it. Yes, she'd really run away. She'd argued with her husband during the night. In the morning she had quickly filled her trunk with the few things she owned and had left. She'd sold her jewelry. In Naples she'd telegraphed her father, letting him know that she was boarding the ship. She'd done everything with a precision that now shocked her, without thinking, she who had never even looked at a train schedule, as though someone had guided her every move.

All right then, yes, she'd done a crazy thing. But she was

in her house now. She could stay there. Wasn't *this* her home, where she was born, where her youth had blossomed like a beautiful flower?

She was exhausted. The recent events began to blur and trail off.

She watched the lighthouse beam shining across the water. She had recognized it with such joy, as if she'd been transported back in time, as if the lighthouse in that peaceful night were welcoming her home.

Downstairs, stunned and dismayed, they were talking about Vanna, discussing what they should do. Who was going to take responsibility for sheltering such a young woman who'd run away from her husband's house? . . .

• • •

"Oh, Vannicchia!" exclaimed Maria, caressing her sister-in-law's hands. "And so? . . ." she asked hesitantly.

"And so. . . . Oh, but that's right! You have no idea what Rome is like. To be alone, not to know a soul; to spend your days waiting for the only person who is supposed to love you just a little. . . . He stays out almost all day. He's always busy. His office is far away. Most times he just grabs a bite to eat in a small restaurant. It wouldn't be possible, you understand, to come home for lunch every day. The distances are too great. And then in Rome, they have different ways of doing things. Some evenings he comes home with two or three friends. Lawyers like him. People who write for the newspapers. They talk for hours and hours about things I don't understand: politics, theater,

philosophy. And so in the next room, I feel like some worthless thing tossed in a corner. One of those rag dolls I used to make when I was little. I'm not a part of the life he leads. Whenever he does notice me, it's only to complain. If we go out, he practically gets embarrassed because I must look ridiculous in dresses I wore when I was younger. I don't know anyone. On the streets of Rome I feel like an ant, but he knows everybody. It seems so strange to me that one can have friends in that crowd that rushes about without ever pausing. . . . One day I sold my little gold watch, it was useless to me, and I bought a brand-new blue dress. He liked it, and he took me to the theater once—he has free seats. But then I felt terrible because I realized he might be just a little more affectionate if I weren't so poor, and I . . ."

"But you were wrong!"

"To do what?"

"To spend your own money."

Vanna smiled, lacing her fingers together. "I wish I had my own! And besides, he always says that in a city like Rome you need to teach yourself how to make a little money one way or another. The fact is he wasn't at all surprised about what I'd done."

The two of them talked in quiet voices on the terrace that overlooked the water. Vanna spoke without bitterness.

She saw the sea, the beautiful sea of her youth that greeted her from a distance, its pearly foam spraying onto the deserted beach. She was happy she'd come back. A beneficial languor soothed her nerves, and she suddenly fell quiet, overcome by the need for silence.

Maria's voice shook her.

"Vanna!" Maria was saying. "Why didn't you talk more openly when you came back the first time? Why didn't you write, after?"

"Why?" repeated Vanna. "I myself don't know why. When I came I hadn't even been married a year. I never thought it would always be like that. Write? A thousand times I was on the verge of writing! But then I saw the reason for my unhappiness vanish. I couldn't find the words to explain myself. Really, what would I have complained about? What do I expect? That he feel sorry for me? That he love me just a little? You don't ask those types of things. It isn't his fault, and it isn't my fault. He was deceived. He needed a different kind of wife. Rich. Well educated. I'm nothing but a weight around his neck. Why are you looking at me like that? It's the truth. Don't be frightened. I'm calm. I was upset, but now I'm fine. You see, I didn't even bring him a small dowry. And yet with a little capital in his hands, he could have started the newspaper. It's the truth."

"The newspaper?"

"Didn't you know? It's one of his lifelong dreams. Just leave me in peace, Maria. Why does it matter to you? Look at the sea—it's so beautiful! You don't know what it's like, this longing for the sea. I could smell the scent of algae in the letters all of you wrote to me. You don't understand anything, my little Maria."

Maria sighed and exclaimed in a low voice: "And Viola? And Remigia? There are too many of us!"

Vanna wasn't listening to her. With hands clasped behind

her neck she was staring at a sailboat passing into the rosy horizon. Below the terrace a fisherman was running barefoot, balancing across his shoulders two baskets that left behind a strong odor of fresh fish.

Vanna felt that all this was enough. She enjoyed the company of Maria, her sweet sister-in-law who had arrived so many years ago in their home, welcomed like another daughter, like another sister.

She was small and dark, like herself. And she reminded her of happier days when she was younger.

No, Vanna didn't like her other two sisters-in-law, it was true. She admired them because they were strong and shapely, but she knew she would never love them.

While Vanna talked on the terrace, you could hear their imperious voices calling Ninetta and giving orders to the maid. They alone were in charge of the house. They kept the keys and took care of all collective business. Their own in-laws were accountable to Remigia and Viola. The two of them always agreed, even when contradicting others and especially Maria, who had a meeker nature. They were difficult because their authoritarian spirit demanded it.

When Maria tried to talk humbly about Vanna to Remigia, the latter would cut her off, saying that Vanna really had gone too far and that it was her brothers' duty to write Rome and notify their brother-in-law.

Once Vanna found out, she begged Nenè not to write. It was useless and mean. Her husband didn't know; he couldn't have any idea where she was. Why tell him?

"I won't bother you," she murmured, frightened. "I swear it."

"You clever little thing, right out of a novel!" said Nenè, smiling. "Don't tremble like that. I'll just tell him that you gave us all a pleasant surprise. Okay? But he still needs to know precisely how things stand."

Reading over the letter, Vanna felt a bit more reassured.

But soon, just seeing the postman pass under the terrace made her nervous again. He was the same postman, rather old, who had delivered her fiancé's letters. She had waited for him so many times on the terrace, on certain beautiful mornings that she had never again seen, when the sun was brighter and the sea bluer, when the sounds that came from the sky, the sea, and the street were deep and deafening like the beating of her heart; when everything was smiling and fresh like her lips that repeated: "Please God, let him have written!"

He was the same postman. But now she watched him pass full of trepidation, hoping that he wouldn't stop for her. She was afraid of the response from Rome, and yet she had no idea of exactly what it was she feared.

She spent leisurely mornings under the rose arbor next to Maria, who was working. They recalled small, insignificant moments in a not-too-distant past.

"Do you remember," asked Maria, "when you wanted to try on my wedding dress? It fit you like a glove. And I was convinced that would bring you good luck."

"That's right. . . . I was eighteen, and you were twenty-four. We were the same height. You see? I stopped growing so I could always be like you."

Maria was sewing a layette. Vanna helped her now and then, weaving a ribbon or attaching lace. At times, her mind drifted off with the tiny garment on her lap.

One morning she said in a hushed voice: "I was expecting, too . . . do you remember?"

"Yes, my poor Vanna. We felt so bad, all of us did."

"I would have loved him so much . . . but he disappeared, too, before he had a face, even an expression I could remember. What little outfits I would have made for him! It must be something so sweet," she added, bowing her head slightly. "I think a mother's heart must melt when her baby's little searching hands brush against her face. . . . Him? No. He doesn't like children."

Maria was crying, and Vanna looked at her amazed.

"Why are you crying? That's the way it happened. Maybe I wasn't even worthy enough to be a mother."

Maria was Vanna's confidant, the dearest face that brightened her father's house.

"You see, I'd never talk to Mama about these things," Vanna would say. "I don't know why. Either I've changed or she has. I've tried to talk to her the way I did before, when she welcomed all my childhood secrets. But it's not the same. She doesn't hear beyond the words I say, she doesn't see all that is dark and deep and unexplainable in my soul. My words echo back from her tired, heavy heart without the warm affection I always used to feel. I've done nothing but manage to frighten her, to make her cry. It makes me sad."

"Really, it is sad," added Maria. "But you still need to

explain your reasons to someone. I know everything. What about the others?"

"No, no," exclaimed Vanna. "I open up with you because you understand me. The others wouldn't understand. They'd say it was all romantic nonsense. Don't tell them anything, Maria. Believe me, our house has changed. . . ."

Even Ninetta seemed different. She was short tempered and cried like a baby if no one accompanied her in the evenings to hear music in the square. At nineteen she was terrified of remaining a spinster, subject to one of her sisters-in-law, since she didn't have a dowry and her parents were old.

One evening they called Vanna into the living room. There were visitors. An old acquaintance was shocked that Vanna had come alone.

"From Rome?" she repeated, shaking her head.

"And her husband allowed her to leave?" exclaimed Viola's godmother.

They looked squarely at her with an air of suspicion, asking questions and making blunt comments.

"What? You don't know how long you'll be staying?"

"What an idea, letting a young wife go off like that! It's nothing to make light of! Coming alone from *il Continente*. . . ."

Vanna left the room with an excuse. Later, she saw Ninetta in tears.

"What's wrong?" she asked sweetly.

"What's wrong," said Ninetta staring hard at her, "is that people are malicious. That godmother went on and on when

she was alone with us, and we didn't know how to answer her. . . ."

"It's such a normal thing . . . that I would come to visit you . . ." said Vanna in a timid voice.

"Oh really," repeated Ninetta, sobbing. "Well, your behavior certainly hasn't escaped anyone's attention around here!"

Vanna looked sadly at her younger sister, who was speaking to her like that, in such a harsh tone. She went back out on the terrace without answering.

After that, it didn't surprise her when they left her home alone on visiting days. It seemed her presence only pained them, reminding them of how difficult she had made their lives. They'd practically forgotten about her anyway.

When it was time for morning coffee, Viola prepared it for everyone and would then say: "Oh, I've forgotten about Vanna. . . ." and she would fill another cup. No one was in a hurry to call her, but oftentimes, Maria went to look for her secretly.

At the table everyone kept an awkward silence. Ninetta would lower her eyes to her plate, and her father would ask timidly for wine, looking about confused. Everyone was fearful of everyone else because they all felt guilty for having permitted Vanna's rash action. And Viola's cold, clear eyes and Remigia's knitted brow were full of reproach. If Vanna had been raised properly, if Vanna had known that she'd not be welcomed home with open arms, then maybe Vanna wouldn't have decided, just like that, to pack up her things like a gypsy.

Her mother felt the guiltiest of all. She had failed to

inculcate in her Vanna those sentiments of submission and sacrifice that are a woman's principle virtues. The older woman had obligations to her youngest daughter, too, to Ninetta, who could end up with a bad reputation because of her sister's failed marriage.

Finally, Vanna stopped going out altogether. She realized that Ninetta was ashamed of her; it was as if the whole town knew all about her flight.

"I'll stay home," she would say, "I really don't like seeing people."

Maria would have accompanied her to the beach, where in the evenings you could go out even without a hat. But Antonio already took that road twice a day to the office, and he preferred taking his wife to the movies or to the café.

"Go ahead," Vanna would say, smiling as Maria embraced her with an air that begged forgiveness. "I'll enjoy myself out here on the terrace."

Viola and Remigia went out with their husbands, too. And because Ninetta wanted to stroll in front of the Café del Corso, she dragged her mother along. The poor woman was no longer recognizable. Exhausted from trying to keep peace between herself and her daughters-in-law (and everyone knows about mothers-in-law and their reputation), she would have preferred to live alone with her husband. But she stayed with her sons, in part because she loved them and, more so, because her husband's small pension would never have been enough to make Ninetta look like a good match.

In the evenings Vanna would stay out on the terrace till

late. She didn't suffer being left alone. In the night's silence she listened to the murmuring sound of the sea and the waves that crashed onto the shore. A random rose would sometimes brush against her hair. She felt that her spirit was at rest.

There were no answers from Rome. But then, when she was no longer expecting it, a sharp letter arrived. The lawyer wrote to his father-in-law saying that Vanna's departure had been a flight undignified of a respectable woman, but that he was willing to forget everything "together with the inevitable anguish that arises out of married life."

The letter made a good impression.

"The devil isn't as bad as you depicted him," said Antonio.

And Viola added, brightening, "The truth is you can't really know a man judging by what others say."

From that day on, they treated Vanna with the utmost consideration. Viola and Remigia urged their mother-in-law to carry out her duty.

"When you have solid principles . . ." repeated Remigia. "I, for example, would never leave my home, even if Nenè isn't exactly an angel all the time!"

"Certain things you just need to accept!" said Viola. "When you don't bring two cents of dowry to a marriage, you can't have too many expectations."

Viola was proud to have had 30,000 *lire* in cash that allowed Luigi to form a business partnership with Nenè.

The older woman was mortified.

Even Antonio, for however much Maria tried to soften his stance regarding Vanna's fate, grew more and more con-

vinced that his sister was being unrealistic. Since he and his brothers worked in the same office, they used to tell him this over and over.

"My dear!" exclaimed Viola, pursuing her sister-in-law as far as the hidden corner of the arbor, "there is no such thing as a bad or a good marriage, but there are prudent women and foolish ones. . . ."

Vanna tried to protect herself from their persistence, which was often vulgar and came at her from every direction.

Finally, she quit caring about justifying herself. Worn down and distant, she only heard Luigi's reasoning, her mother's begging, her sisters-in-law's advice. They talked to her of nothing but a future full of dangers and responsibilities. When they did force her to respond, she always nodded in agreement: "Yes, yes. . . . But leave me alone now," she would plead.

And deep in her heart she felt that her father's house, now altered and transformed, was slowly pushing her out.

"You can't go back!" whispered the soft and fragrant roses that brushed against her hair.

"You can't go back!" warned the sea from afar, casting its silver foam onto the shore as though it meant to reach her terrace.

You can't go back. Everything changes. Your brothers have another face. Your mother another voice. Other women have taken your place while you were away. And each one of them welcomes you the way they'd welcome a passing stranger.

Vanna listened to the solemn words in the pitch black night.

"Oh, sea of my childhood!" she murmured, entwining her hands behind her neck. "I've passed you twice with a heart full of hope, when I left home and when I returned. My sea! You were the only one who welcomed me the night I came back. . . . Can I pass you one last time with just a little hope in my heart?

• • •

"Here," she said, holding out the letter, still wet with ink. "I've written him."

Her face was a little more pale than usual, and you could tell she'd been crying. But her expression was sweet, the way it always was.

She read in a strong voice to the family—everyone was there because they were waiting for dinner to begin—those few words asking her husband for forgiveness and begging him to come and take her back.

Folding the sheet, she scrutinized each of their faces.

Everyone was silent. Maria, who was in the back of the room, wept quietly.

"Except," said Antonio, his voice breaking with emotion, "I'd leave out the last part. Why tell him that you want to return? That's up to him, if he wants you to."

Viola shot her brother-in-law a look of reproach. Vanna noticed it and said calmly, "What good is it just to ask him for forgiveness? Forgiveness for what? You all know I did him no wrong. The point is this: I have to go back."

"But no!"

"You're in your own home!" they all said at once.

But their voices sounded unconvincing, almost intimidated.

Vanna headed back to her room. Passing Maria, she put her arm halfway around her growing waistline. "You silly thing! Why are you crying?" And she pulled her, still smiling, toward her bedroom, the "cat's room." There, where the others couldn't see, she wept, too, with her face on Maria's breast.

"It had to be," said Antonio. "Vanna's twenty-two years old. She can't start her life off with a scandal."

They all wanted to convince themselves that they'd done their duty. But they felt uneasy, disquieted by a strange apprehension.

Only Ninetta was happy. She hurried off to explain to her godmother and her friends that Vanna was leaving, called home by her husband, who adored her and couldn't live without her.

Since no one was the head of that house, no one had the courage to be sincere; none of them dared say what was really in their hearts.

And so as Vanna prepared her trunk, they became indignant, insisting that she was in too much of a rush to leave, that no one was forcing her out. They said these things mostly to persuade themselves, since all of them knew they had been too hard on that poor creature, who had only come back to her father's house looking for a measure of love.

Vanna responded sweetly. "It's better that he finds me ready. He won't stay long, you'll see. And besides, what's the point of putting things off when we have to say good-bye?"

When no one was looking, she placed some rosebuds from *her* terrace in among her undergarments. It was something at least, from the places of her past, places that might also change before too long.

She tried to comfort Maria. "You'll see," she said, "I'll be better behaved in the future, and my luck will change after this."

She truly hoped so. Now that she felt herself being pushed out of her father's house, she could only cling to her husband. Waiting for him, she forced herself to remember him in his good moments so as to find some reason to believe in the future.

And now, almost impatient for him to arrive, she begged first her father and then her brothers to put a good face on things. The night he arrived she insisted that at least Luigi go to meet him.

He made a wonderful impression on Remigia and Viola, who had not yet made his acquaintance. His black well-trimmed moustache, the monocle he carried attached to a gold chain, his light-colored suit, everything about him pleased the two women, who, without intending to, compared him to Luigi and Nenè, stuffed into their comfortable clothes made of rough, checkered material.

He had no sooner entered the room than he began to explain, as though it were indispensable, that he'd been to the Argentine Theater to hear a celebrated actress who had returned from *La Mèrica* and that he'd written an article critical of a Milanese lawyer who was in fierce competition with him.

He spoke with emphasis and affectation, almost as if he

weren't addressing relatives, but rather a group of friends gathered together for a brief moment. He seemed to have forgotten the point of his long trip, and he made the others forget, too. Yet if his gaze met that of his wife's, it would turn hard and cold. And then a painful trembling that ran from her head to her toes seized Vanna.

"Yes," he said as he made his way to the "cat's room" to get cleaned up, "being in charge of a newspaper means having weapons at your disposal."

When Vanna closed the door and was alone with her husband, he appeared drained and his face dark. Without looking at her he said slowly, "What in the devil did you tell your family?"

"Nothing. Don't you see how they welcomed you?"

He calmed down a bit, but his look was still hard.

Behind the glass of the monocle his eye appeared dilated and somewhat red. Vanna's own vision was clouded. She saw her husband with that single eye, big, monstrous, and round like that of a Cyclops. They didn't speak. They had nothing to say to one another.

He stripped down to his vest to wash, and while drying off, asked: "Who gave you the money?"

"What money?"

"To get down here."

"I . . . I had some."

"And now?"

"What do you mean, now?"

"How do you think you're getting back?"

"But . . . you . . ."

"But you," he repeated. "Do you think I carry money around in my suitcase?"

Vanna bowed her head. He drew close to her and said in a low voice: "I came because you wanted me to. I didn't feel the need . . . to leave. I didn't know I'd have to pay for your trip back, too."

Vanna remained silent.

"Do you understand?"

"Yes."

"Good, you'll take care of it then. It's already enough that I've come. You've got three brothers and a father. . . ."

"Yes," replied Vanna.

It seemed to her that she was already back in the Rome apartment on the fourth floor. She was extremely pale, and her ears were ringing as though she had drunk quinine.

"Where are you going?" asked her husband suspiciously.

"Out on the terrace. I need some air."

"Be careful!" he warned, in a voice that was somewhat kinder but firm. "If you make me look bad . . ."

"Don't worry."

Vanna went out slowly. Passing through the dining room, Maria shouted to her from the terrace: "Vanna! They want me to prepare the strawberries. Should I fix them with lemon juice or *marsala*?"

"Whatever you want, Maria," she answered. "All right then, make them with *marsala*," she added, since her sister-in-law was insisting.

She went down the stairs and out into the street, keeping close to the wall. A man who was passing eyed her curiously, then said something to her.

Vanna started running toward the coast, headed straight to the water's edge. The wind was blowing through her hair. A surge of water swirled about her feet. . . .

Ciancianedda

❧

Massaro Peppe was whittling very slowly on his doorstep, making himself a flute, pushing out his lips with every cut of the small knife that he held tightly in his measured, heavy hand.

"So you feel like playing, *massaro* Peppe?" said Graziano, coming forward with his lazy walk.

"I've always played. What would I do up there like a dried twig while the sheep graze? I play, and I forget about my troubles."

"Could I have two words with you, *massaro*?" interrupted Graziano, stopping.

"Four if you want, my son."

"But not here. There, in your house."

"Are you crazy? No one has ever set foot in my house. Do you forget I have a daughter?"

"*Massaro* Peppe!" said the young man, pushing back his cap. "It's exactly Ciancianedda that I want to talk to you about."

The farmer's hands trembled slightly as they began cutting into the stick.

"You know, we've had eyes for one another for a long time. She's as beautiful as ripe grain and good as bread. I . . . well, you know me. I don't have any vices. I've never been in trouble with the law. And I'm not someone who doesn't own anything. You see, it's no use. You know me like a son."

Looking stern, *massaro* Peppe turned the stick over in his hands without cutting because he was thinking. Then he said slowly, "I'm not marrying that girl off. You know that."

"I know. But the love I feel for her is strong, and I understand her just as if she could speak."

"And I'm telling you to leave her in peace because it's not right for a decent young man to make her lose her head. Today you say you don't care about her sickness. But tomorrow, when your passion's cooled, tomorrow you'll care, and it will be a burden to you. It's our cross. It's already been four years. Before, it seemed she would die . . . and then . . . I don't know if it was better or worse. . . . She's the kind of creature that if you don't respect her, she'll die of a broken heart, little by little, without letting anyone know, like a flower that withers on the stem. I show her respect, and her brother does, too. And her mother did as well, blessed soul. You can betray her in all kinds of ways behind her back, and she doesn't hear you. You can hurt her, and she won't hate you."

The old man appeared to be carefully studying the flute he had carved.

"I swear on my father's soul," responded Graziano, "that

I'd cut off these hands before I'd hurt a hair on her head."

They talked for a while longer. And finally *massaro* Peppe pushed the door open, allowing Graziano, who had remained at the entryway, to come inside.

"I'll give her to you. But who will keep us like this from now on?"

Graziano looked at the polished copper that shone on the smoky wall; the spotless floor, recently washed; the swept hearth; and on the dresser, the gold-rimmed cups turned upside down, four oranges, and the pictures of the saints. The old man also opened the chest to show him a bolt of bleached cloth. He had barely lifted the lid when he suddenly let it fall, saying:

"Women's business, these things. She was sixteen when she got sick. Do you remember? And sixteen and a half when her mother died, the sainted woman. Since then, alone and so young, she's kept the house going like clockwork. Right now she's spinning wool, and after that she'll set up the loom. She even sews the *scappulari* by herself. Around the house, she's a bee. And the way she used to sing before! Do you remember? Just like a little tinkling bell, a real *ciancianedda*. The nickname stuck. . . . She still smiles all the time, even when she shouldn't. . . . Go on now. She's out with *comare* Orsolina at benediction. You can set foot in here again on the day of the engagement."

And *massaro* Peppe went back outside to finish his flute and stayed there until Ciancianedda got home. He followed her in right away, frowning, and sat down on the bench.

Then Michele, his son who was so big that he had to bend over to pass through the doorway, came in, too.

And while Ciancianedda was down on her knees, blowing under the hanging pot that swayed back and forth, father called son and announced without looking at him: "Today he told me what he needed to tell me. It's useless for you to talk to him. . . . He really wants her," he added, pointing to the girl whose hair appeared to be made of copper in the flame's bright reflection.

"And you, sir?"

"They love each other," said the old man, sighing. "Your sister is sewing her *corredo*, and I believe in her heart she thinks about getting married. One of these days she could do something foolish without realizing it."

"He'd better forget it, that bum!"

"They love each other, Michele. They understand each other the same as if they could talk to one another. You can't put love out like you do a fire."

After the engagement, *massaro* Peppe allowed the couple to see one another every evening when Graziano returned from San Martino. Ciancianedda was always there on the doorstep spinning furiously, thick and thin, lowering her timid and laughing eyes each time Graziano bent over her, his face lit up by pleasure and desire. They spent hours that way until the moon came out.

The neighbor women exchanged furtive glances, remarking with disappointment,

"What a pity. He's gorgeous as Saint George. . . . As if he didn't have other girls!"

Ciancianedda didn't notice a thing; she didn't see the resentful faces; she forgot completely about her own misfortune. Under Graziano's gaze, she seemed smitten by the July sun.

But at night, when the darkness worsened the silence that enveloped her, she would feel her heart tighten, thinking that she would never, ever, be able to speak to Graziano with her own voice. She recalled the good times when she was like all the other girls. She knew how many things you can say with a voice, how many things you can hear in just one small word. She remembered when she used to go to the *quota* with her mother, running to look for blackberries along the very hedge that separated Petranìca from San Martino. Graziano used to come work the land at the riverbank. When he saw her he would set down his hoe and sometimes say, "Oh! Ciancianedda! What have you come looking for all the way up here?"

"Blackberries, look!"

"Is that right? Well now I'm going to help you search for them!" And he would make as if he were going to jump over the bush. And she would run away shrieking and take refuge in the haystack.

"What's wrong?" they would ask her. "Why are you so red?"

"It's nothing! I saw a snake in the grasses."

And she would laugh. And then she'd sing at the top of her lungs, feeling as if her soul were being carried away under the blazing sun, into the clear sky. What times those were!

Once Graziano really had jumped over the bush and,

seizing her by the arm, had planted his lips on her cheek, searching for her mouth. She'd run away then, too, with her legs trembling, carrying that kiss in her blood the same as if the sun had seared her veins. Since then she had never gone back to pick blackberries along the hedge, and whenever she saw Graziano she would lower her eyes. Even now, on this cold night, she felt the burning desire of those lips that tasted like the sun on her cheeks.

What had happened after that? She'd gotten sick; that at least was certain. But as for the illness, she remembered nothing; and she had only vague, faraway memories of her recovery. She had felt herself getting better little by little, like someone whose sleep is broken by frightening dreams that are impossible to describe. And then she awakened wrapped in silence. A leaden silence that weighed heavily on her heart and ears.

In the dark night she feared her approaching wedding and fell asleep crying. But with the light of day her sad thoughts vanished, scattered amid the kitchen items she went about touching and that had been, for four years, a little like her godmother, a little like her father: things without a voice, but good things.

The time soon arrived to wash the fifteen items that made up her *corredo*. It was August, and so she went to the countryside, laying everything out to dry. Then she ironed each piece and spread everything out on the beds, on top of the dresser, and in the long baskets so that the whole house was filled with the scent of new cloth, and her acquaintances said admiringly that only the *corredo* of a rich farmer's daughter could possibly

be finer than that of Ciancianedda. Graziano had already bought the gold jewelry, a shawl, and two dresses—one charcoal gray and made of good-quality wool and the other, of shining yellow silk.

They were married on the Feast of the Virgin; and Ciancianedda, on her father's arm, followed by Michele and the groom and all the guests, stepped into her new home.

While *comare* Orsolina busied herself seating each guest and passing the tray with roasted chickpeas and vintage wine, Graziano showed his wife the household furnishings and kitchen items. It was all there, from the solid brass bed right down to the oil lamp, everything you could possibly need. On the dresser, in front of a row of pink cups, was a basket of *moscadella* grapes from the first harvest. At the head of the bed, a chubby, curly-haired baby Jesus smiled.

Ciancianedda trembled and smiled, looking around. Her eyes were as lovely as the sea encircling the Lipari Islands when the sky is serene. With hands joined, she appeared to be praying. She was already alone with her love and her immense happiness.

Michele and the guests were chatting, munching happily on roasted chickpeas; only *massaro* Peppe, staring at his boots, kept quiet like someone thinking about difficult and painful things.

Comare Orsolina handed out fistfuls of chickpeas to the couple; then Graziano filled a glass and offered it to Ciancianedda. She took it, but her hand was shaking so badly that all the wine spilled onto her yellow dress.

Michele and the others froze. *Massaro* Peppe pursed his lips, looking at his daughter. Bewildered, Ciancianedda stared down at the spot, red as blood, that spread across the shimmering dress. She felt the wind of ill omen that passed through the room, shadowing every face.

Comare Orsolina was the first to come to her senses.

"Spilled wine is a sign of plenty!" she exclaimed. And she tried to help the bride, who had fallen to her knees in front of the bed, back to her feet. But the sobbing girl was inconsolable. She was alone, with her bad luck.

• • •

Ciancianedda was waiting for Graziano, who had gone back to San Martino. The languid feeling that comes with being a new bride had tired her slightly. She walked around the room touching and caressing the headboard, the dresser top, the chairs one by one; each thing belonged to her. And Graziano, handsome, strong, and healthy, was hers, too, and he loved her. The thought warmed her blood with sensual delight and desire.

Every minute seemed like an eternity, and as dusk approached she no longer dared to move about, because she feared the dark like an enemy.

When Graziano returned she shook with happiness, almost as if she'd been lost and had found him again. She helped him take the harness off the mule and unloaded the saddlebags by herself to show how strong and useful she was. Then she stripped off his muddied goatskin leggings, dished up his soup, and served him, gazing at him all the while with passionate humility.

That look of hers was full of longing and sweetness, like a cluster of ripe grapes, and she stared at him anxiously for a long time fearing she might not understand quickly enough.

Her happiness was continually upset by worry. She would have liked to swear her fidelity: to hear just one word, even an order. She longed to know all his desires, all the habits of the man she loved. And unable to ask anything or promise anything, she constantly searched that still-new face, struggling to read it well.

She didn't like going out. She only went to get water in the evening or at dawn when someone could accompany her because she feared strangers and unfamiliar faces. But one evening, Graziano gestured that it was time for her to start going alone. Ciancianedda obeyed and crossed the deserted street, keeping close to the wall. At the fountain she found the usual neighbors. One old woman who was always there said: "Is this the first time you've come by yourself? You were from the neighborhood of Sant'Antonio, if I remember. . . ."

Thinking they were greeting her as they'd done when she was with her husband, Ciancianedda smiled sweetly.

Observing her, the old woman knit her low brow and said to a dark, shapely girl, "Oh, Silvè, the bride is the one Brasi was telling us about. *Massaro* Peppe's daughter. A real bargain, to be sure!"

Seeing them talking, Ciancianedda cast her eyes about, looking lost. She studied the girl, who was big and provocative, and she felt small and pitiful.

Silvestra looked at her with curiosity, swaying her hips

back and forth; then she pushed the deaf bride's pitcher aside and put her own in its place. Ciancianedda turned pale beneath the stare of those mocking eyes, so black it seemed they had been made with the dye used for *orbace*.

She hated her, just like that, suddenly, with her whole soul, not knowing why.

From that time on she only went to get water in the morning, at dawn, when there weren't any people at the fountain yet.

Her father and Michele had now closed up the house and were staying in Petranìca; one tended the land, and the other took care of the goats, on the knoll at Erva.

When her father returned once a month, he came to see Ciancianedda. Sitting down, he would ask her with a hand gesture: "What are you doing? How are things going with you?"

She explained herself by pointing to things around her. Wasn't it obvious that she was getting on well?

"And people?" her father asked, motioning toward the street.

Ciancianedda shrugged her shoulders, laughing. She didn't pay attention to people.

But *massaro* Peppe knew his daughter. And if he found her to be the least bit upset, he would wait for his son-in-law to give him a tongue-lashing, saying, "Watch it. If I find out this much, just this much . . ." and he would press his thumb to his forefinger.

"But what are you thinking, sir?" said Graziano, cheerfully. "We're two doves in a nest."

And after his father-in-law's visit he would sit for a long time next to Ciancianedda and the day after bring her some of the first fruits and vegetables from San Martino.

Sometimes her godmother also visited. While adjusting her apron, so stiff and shiny because it was never washed, she, too, would ask Ciancianedda: "And people?"

"It doesn't matter. I'm always in here," Ciancianedda explained, pointing to the closed door and the stool set under the door grate.

• • •

Toward sunset, the street echoed with Silvestra's singing, a sharp, quivering voice that vented and challenged defiantly:

"This much I'm telling you, my cinnamon flower
Your house is low, and the girl is beautiful."

There were times when Graziano passed her on his way back from San Martino and, spurring his mule along, would say, "Oh! Silvestra. A caged bird sings either out of love or anger."

"It's more likely that he sings out of love."

"And for you, which is it, Silvè?"

"Who my love is, I'm not saying, to you or to anyone else."

And with those almond-shaped assassin's eyes, she looked up at him from below.

*"Now you're without, now I'm without
Time passes and yet we never love one another."*

Graziano used to then come home in a bad mood, and while his wife watered the mule, he waited, with outstretched legs, for her to strip off his leggings. Ciancianedda served him meekly, watching always with taut nerves to see if he needed anything. She had learned to read that face well; a face that of late had been angry or irritated. She wanted to ask him why he was upset with her, if he was holding a grudge for something she'd forgotten to do, without realizing it. But it was difficult to ask such a long question with gestures. She tormented herself trying to find a way to make herself understood. One evening she thought she'd found it. She knelt in front of him with her hands joined. He shrugged his shoulders then pushed her away, without looking at her, and went out on the doorstep.

Motionless and on her knees, Ciancianedda continued looking at Graziano's figure, black against the white light of the moon.

He was leaning against the doorjamb, breathing in the fresh March air like a man just released from prison. Ciancianedda trembled, her blood burning from pain and passion. What was he holding against her?

She got up and approached him slowly on tiptoe, touching his arm timidly. Graziano didn't turn around. He was listening.

Ciancianedda began to weep aloud. A cruel, sharp voice was singing:

"All your songs I've stolen from you
Your love I've utterly bewitched
And you will die of a broken heart because of it."

Maybe Graziano was tired of seeing her cry. She looked at herself in the little mirror she kept among her combs and saw her puffy eyes and colorless cheeks. He had liked her because even without words she still had a serene manner that always reminded him of the Ciancianedda of old, of the Ciancianedda who sang in a full voice like a bird in springtime.

And the whole next day all she did was wait for him to get home, to show him how she'd changed. But he came in after dusk, long after every peasant had returned from his *quota*. His face was dark. As soon as he finished eating, he lit his pipe and sat down outside on the doorstep.

Ciancianedda watched him intently. She saw him spellbound, listening. And his face seemed to brighten.

What voice was rising up in the night? What voice could please him that much?

She felt more sharply than ever the pain of that deathlike silence that bound her ears. No gift on earth was greater than the one she had lost when she was sixteen. Not beauty, not money, nothing linked two creatures together like the power of the spoken word. A word that can often be sweeter than kisses. . . .

The next day *comare* Orsolina found her with reddened eyes and again repeated her vigilant questions. But her goddaughter smiled. She was happy, she was. Graziano treated

her splendidly, like a piece of fine gold in the palm of his hand. Why had she cried? Just imagining too many things . . . fantasies.

Her godmother shook her head. Then she said, "Listen." Touching her eyes with her index and middle fingers spread wide, she pointed toward the street.

"Look around?"

When she was alone Ciancianedda fretted over the thought, consumed with anguish. Look around? She opened the door and sat down to spin outside. It was the first time. She had never dared to mingle with the strangers in that unfamiliar neighborhood.

Everyone in the vicinity was out in the cool March sun. Ciancianedda saw the girl with black eyes that looked like they'd been made with the dye used for *orbace*.

A woman who was mending exclaimed, "The bride has come out."

"So she's done snubbing us," added another.

The old woman murmured, "Still, she has a kind face, the poor girl."

Seeing that people were talking, Ciancianedda suffered the same as if a hundred pins were jabbing her skin. And yet she refused to think about going in.

But when Silvestra passed directly in front of her, moving her hips and looking straight at her, Ciancianedda stiffened and went back inside, slamming the door as though they had slapped her.

She kept the door slightly open and sat down again below

the grate. But she stopped spinning. Hidden from view, she peered out the door to watch her pass; and staring at her with eyes full of curses, she began to tremble the way she did when she forgot she was deaf and thought she could still speak. She tried to pray, but she stopped short. Even the desire to pray had been poisoned. Silence, her mocking enemy, filled her with terrible, frightening thoughts.

She wanted to confide in her father, but when she saw him so resolute in all his gestures, she immediately regretted the idea, fearing for Graziano. You don't start a war between two men.

Instead, she smiled to make her father understand that she was happy and lacking nothing.

Graziano came in after one in the morning when the soup had gotten cold on the fire, which was half out. She was waiting for him, curled up in a corner in the dark. The words that she couldn't pronounce formed a lump in her dry throat.

Why are you coming back with your saddlebags half empty? Don't they harvest the first broad beans, all tender shells and downy fuzz, in April at San Martino? Last year you brought me a basketful for our engagement.

The words were suffocating her; and she moaned loudly, like a little dog that's been beaten.

One evening she waited for him outside, where no one could see her. He came back before dusk and stopped in front of the other house. He unloaded his saddlebags, helped by the other woman. Then they shut the door.

Ciancianedda came back inside, shaking as if she had

malarial fever. Maybe this had been going on since they were married, maybe even before. . . .

She waited for him, crouched on the doorstep with her chin on her knees. She wasn't thinking anymore. She felt as if she'd been on that doorstep for years, tossed there like some dead thing.

When he arrived, she raised her disheveled face, moved her lips, and then extended her hands.

She wanted to push him away. She wanted to stop him. In her wide eyes there was an overpowering will to speak. She wrapped herself tightly around his knees. Graziano's face was red and his veins swollen, like someone who'd been drinking heavily. He pushed her away, then shoved her into a corner, striking her.

Her father had never hit her. Never.

She wanted to run away, but she stopped at the doorway. The house was all closed up now. The men were in Petranìca.

Still, there was *comare* Orsolina, she would open her arms and comfort her. . . .

She made a desperate gesture toward the dark and deserted street.

Graziano laughed, pointing at the doorway with an ugly smirk on his blazing face. Leave? Fine, do as you please!

Leave. . . . Now he was mocking her. But her house was all closed up. And the men were in Petranìca. There was only *comare* Orsolina. And then? When her father and Michele found out that Ciancianedda had been mistreated?

No, you can't plant hate and rancor between men.

Graziano had flung himself down on the coarse wool blanket and shut his eyes. Exhausted, she let herself fall onto the bench.

In the colorless dawn she rose to her feet. Maybe she had dozed off for a while. She was shivering from the cold, and her head was dull, her mouth bitter.

Graziano was in a deep sleep, breathing heavily; his open shirt exposed a chest and neck that looked like shimmering bronze.

Ciancianedda gazed down at him.

There was only one thing to do. The colorless dawn told her so, as did the mocking silence, weaving its dark shroud.

• • •

Like the noise from a drill that turns without stopping, a stubborn thought made her temples pound. And her eyes now had a cold, metallic luster, like the darkening skies over Lipari when the southwest wind blows.

When her godmother asked the usual questions, she answered by shrugging her shoulders. She was happy. Couldn't she see that? She was waiting for Easter. Easter that brings peace to everyone, to good people and bad; to friends and enemies. And she counted cheerfully on her fingers: today and tomorrow and then Palm Sunday.

Saturday evening was bitter cold. A dry and icy wind had whitened the street, making it look like it was made of the bones of the dead. Every door was shut tightly. Far off in the distance, dark clouds fringed in red gathered over the sea. A

random window banged back and forth, and a woman who was passing wrapped herself tightly in her shawl and said, "The sky is overcast. It's going to storm."

An old woman carrying a bundle of sticks lamented, "We're going to have a bad Easter this year, to pay for our sins."

Ciancianedda looked out at the sky from behind the grate and shivered. She was feverish.

It was early, and it already seemed like nighttime; Graziano would be coming home late because he was stopping in Petranìca to get the lamb.

Ciancianedda pulled an old *scappularu* out of the chest where she kept her wedding dress with the big stain that looked like blood.

She glanced at the spent fireplace and then went back to search the darkening sky.

• • •

Silvestra was humming away. The fog that was descending rapidly on the town made it impossible to distinguish one house from another.

Graziano would be late. He had to pass by *massaro* Peppe's *quota* because the farmer wanted to give him a lamb for the deaf one.

She heard a soft knocking. She wasn't expecting anyone at that hour, and Graziano couldn't be back yet. Edging the door open cautiously, she glimpsed a man, small in stature, with a hood pulled over his eyes; he was leaning against the wall like a beggar or someone having trouble staying on his

feet, holding the edges of the *scappularu*, which was too big for him, together at his chest.

"What do you want?" she asked him brusquely. There was no reply.

So she cracked the door open a bit more.

"Well, who are you looking for? What do you want?" she repeated.

A hand moved beneath the *scappularu*, then clutched the ends of the cape again.

Two strange, shining eyes, full of terror, were staring out at Silvestra. She quickly shut the door, shaken; she listened intently. Had he gone yet? Then she started humming again to rid herself of the disturbing image.

Ciancianedda took a few steps. Staggering, she fell to the ground in a dark and deserted corner. She let the pistol slip slowly onto her knees. She was no longer thinking about Graziano coming back, or that someone might see her.

Was there, just maybe, a place for her? She was more alone than the beggar who sleeps under the stars, more lost than the child who can't find his own doorstep.

She loathed herself and everything about her life, and she asked God to forgive her the act she had not dared to commit.

An old man who was passing approached her with pity; he thought it was a young boy curled up on the ground, one who perhaps had fainted in the oversized *scappularu*. He asked what was wrong, taking him by the arm to help him to his feet. The cape fell away, revealing a flowered bodice, while a soft, chestnut-colored braid unraveled like a skein of silk.

The old man took a step back but bent down again right away. He'd seen a pistol. He picked it up cautiously. It was loaded.

"What were you thinking of doing, you wretched creature? . . ." he repeated, hiding the weapon beneath his overcoat and looking around, alarmed.

Ciancianedda stared at him with her sweet, passionate eyes full of sorrow. Then she let herself be led down the short street that was still deserted, toward her husband's house, blanketed by the fog.

Red Roses

Rose rosse

"A big celebration, *donna* Bobò?

"God willing, *donna* Mara."

"Have they all arrived, the relatives of the groom?"

"All here, from Palermo, loaded with gifts. Father, mother, sister . . ."

"Can you imagine *donna* Angela!"

Donna Bobò fell silent, as if *donna* Angela herself had suddenly appeared to call on her for something. She was surprised, actually, that her sister-in-law hadn't already interrupted the conversation with their neighbor as she always did. She reentered and closed the window, ever so carefully so as not to make any noise. As she turned, the silver light of the oversized mirror fell across her body, illuminating her whole person. It was then that she looked at herself timidly. Struck by a sort of self-pity, as though seeing herself for the first time, she thought without bitterness that her sister-in-law really had no reason to keep her

under watch anymore. She saw the stooped shoulders, the face full of wrinkles like a forgotten little apple, and breasts that were smoother than a plank and somewhat sunken.

Moving quickly away from the mirror, she continued dusting the living room furniture, passing the rag with measured precision, mechanically, across the intricate leaf patterns of the chair backs. Her small, sure hands hurried along, but her thoughts moved slowly, at their own pace.

She could see a diffuse green light, far away and hazy. It was always the way those few disconnected memories of places in a long-ago past came to mind: the arbor at Licata with its ripening grapes, her mother dressed in black, and she herself embroidering bunches of red roses with stems as stiff as sealing wax onto a bright yellow coverlet. The coverlet, that took forever to finish, was destined for her *corredo*.

Concetto would come by to visit her mother. And he, too, would sit beneath the arbor, accepting coffee and homemade *savoiardi*. He chattered on like a windmill, but if by chance her mother left for a moment, he stopped talking, and she would blush, becoming redder than those red roses, and lower her eyes, a bit happy, a bit frightened, to find herself alone.

And then when her mother died and they closed up the house in Licata, she went to live in her brother's house.

New town, new people.

After a year of seclusion when the bereavement period had ended, in the midst of people she didn't know, surrounded by relatives she didn't love, she saw Concetto again. The first time was in the morning, she had a clear recollection, and it was in

church. Lifting her eyes from her prayer book, she had caught sight of him leaning against a pillar in a ray of sunshine full of gold and silver dust, holding his hat in his hand.

After that, her sister-in-law no longer brought her to the eleven o'clock mass, and she no longer took her out walking along Niviera Street, where he would follow slowly behind them at a distance.

"Bobò, you'll keep an eye on the women doing the laundry in the courtyard."

"The farm manager is supposed to come; Bobò will wait for him."

They still called her Bobò. Time had passed, but the nickname they'd given her back in Licata lingered, like a brief, warm caress. Michelina, her niece, used to call her Auntie Bobò, but now that she was older she just called her Auntie. And Angela, when she did have to refer to her, simply said "my sister-in-law," or if she was addressing the servant, said "the Miss," or "your sister" if she was speaking to her husband.

The childish nickname annoyed everyone. One time Angela said: "It's ridiculous that you still go by Bobò."

And yet no one could quite manage to call her Liboria. It was habit.

In time, she, too, had grown ashamed of being known as Bobò. But the nickname had stuck, much in the same way that her youthful appearance refused to die. It was true. Her hair was too soft and long and her breasts too full, although she tried to hide them (out of modesty) in dark, stiff corsets buttoned tightly.

Concetto had moved to the town where she now lived. He was a pharmacist. He'd asked her brother for her hand in marriage, but he had refused without even consulting her.

She only found out about it afterward. A servant who had been fired told her.

"Open your eyes, Miss! You'll be sleeping alone forever while *donna* Michelina is enjoying your dowry!"

And yet what could be done? Do I say, I want to get married?

A rush of blood flooded her whole face at the impudent, immodest thought. How could she say it like that to her brother and sister-in-law?

So she said nothing. And Concetto would pass every evening in the alley, and Angela would close the windows that faced it. Concetto would go to mass at eight o'clock, walking along the main street of Santo Stefano, and Angela went at five, no longer permitting her sister-in-law to go out at all. Concetto wrote three times, and Angela confiscated the three letters, full of humble, ardent words, tearing them to shreds. The battle between Angela and Concetto was silent and fierce.

One evening her brother, after having listened to his wife, who couldn't tolerate the surveillance any more, ripped into Bobò: he told her that women are all alike, that all they have to do is see a man (any good-for-nothing!) and they lose every bit of self-restraint. Thinking he was doing her a favor, he said brutal, awful things. Bobò listened, almost without breathing, her throat shut tight; she had the feeling of being stripped

naked in front of everyone, in front of her brother, who despised her, in front of Michelina, who was smiling. . . .

And so Angela's job was made a bit easier. Bobò no longer dared to look out the window, no longer dared to go out. She hoped, she never stopped hoping, for a miracle, for love as it happens in novels and fairy tales.

The pharmacist was informed that Bobò did not wish to marry, that she wanted to become a house nun.

And time passed ever so slowly and changed the color of things, like a veil of dust that settles over a forgotten toy. Her hair turned opaque, and her breasts began to fall; her eyes lost their sweet splendor.

Concetto also turned gray and heavy, but he didn't marry. He didn't know how to love another woman the way he had loved Bobò.

Now Michelina was getting married. Her aunt had given her the *corredo* and the yellow coverlet with the red roses, still bright and fresh as her own heart. She'd also signed papers that ceded all her possessions from the Licata house to her niece. She'd given her everything, little by little, and now she was stepping aside for her in life.

"Out of gratitude," people said.

Out of gratitude, of course. . . . Her brother had given her a family; Angela had been like an older sister, a little severe, but affectionate. . . .

And Bobò had moved aside to let the bride pass ahead of her in life.

• • •

"What are you still doing in this living room? There's no time to waste. Get going."

"I'm coming," Bobò replied meekly, stirring herself from her thoughts.

It was late. She worked furiously until evening. Then she dressed the bride, as though she were a living doll. Angela on one side, she on the other, the bride standing in between, looking a little pallid and dreamy.

"I don't like this bow," Bobò remarked.

"And why, if you don't mind?"

"Auntie's right," said Michelina, "let her do what she wants."

She needed to be beautiful, her little one. The groom was from Palermo, and he was used to seeing elegant women. Bobò threw herself into the task with passion. In dressing the bride, she revealed certain signs of good taste, a kind of coquettish grace that she herself had never demonstrated.

Then when it was time, she got ready. She parted her hair into two sections like she always did. It was still thick and long and still difficult to manage, but with so many white strands it looked as though it had been dusted. She took the new dress out of the closet. It was cinnamon with black trim, ordered because it suited Angela's tastes, and it gave off the same acrid odor of newness that you always smelled in the baker's shop. Because of this, to air the material, she opened the window. But she caught sight of the boys gathered outside the door waiting for the groom to arrive, and she shut it again.

"Hurry up!" called Angela. "We have to get the trays up here!"

"Hurry up! We need that new lamp moved into the living room!"

Hurrying. As always. She dressed hastily, without looking in the mirror, and quickly left the room.

She had the servant bring the lamp into the living room, then raced to the dining room to set out the refreshments: the cookies and special sweets over there, the small glasses on the larger tray.

She passed Angela, who was dressed in raw silk and bustling about.

"When you've finished, come in for a minute. It's necessary."

She'd said "it's necessary" in an annoyed tone. She didn't want people murmuring that she kept her sister-in-law in some corner now that she'd gotten her to hand over all the Licata lands.

Bobò gave a start and suddenly became anxious. She wasn't used to seeing people, to being in the living room, but Angela ordered her to go in with that tone of hers that didn't allow for answering back. It was the reason she'd had the special dress made. She had to obey. Like always.

She went down to the living room. Her legs were trembling as though she were the bride with the groom waiting for her. The lights, the chattering, stunned her. She paused for a moment, hesitating in the doorway, hidden behind the heavy flowered curtain; then she moved forward and headed toward the couch where her sister-in-law was sitting in the midst of the guests, like a queen on her throne.

Her sister-in-law introduced her to the groom's relatives, who barely acknowledged her with a nod.

The groom's sister observed her with curiosity through her monocle. She felt clumsy, pathetic, and wrinkled, and Angela was looking at her severely.

"Probably some old spinster they let stay here," the younger woman thought to herself.

Bobò slipped away, practically on tiptoe. She moved the new lamp more to the center of the room because it wasn't commanding enough attention where it was, then looked around to make sure everything was in its place because of her compulsive habit of never resting for a moment.

Near the closed piano, black and shiny like a coffin, was a guest who stood away from the others. He was looking at her. Her whole body trembled, and she approached him.

She saw, a bit confusedly, a gray head of hair, a tired smile.

"*Don* Concetto!"

"*Donna* Bobò!"

They fell silent. They had nothing to ask one another.

"It's been so long. . . ."

"So long . . ."

Bobò's heart was in her throat. The lights, the whispering, the people, everything disappeared in the distance, dancing away. She had the impression of being alone, just with *don* Concetto, in an immense deserted place, feeling as though they should take one another by the hand. They looked at each other for a long time with a kind of anguish.

"So much time!"

"So much time . . ."

She saw how he had aged, and it pained her, almost as if the years had taken their toll only on him, leaving him stooped and devastated. The years . . . that had ruined everything with no means of making things right, that had left her virgin heart fresh and intact.

It wasn't the harsh light that illuminated her eyes but rather the diffuse green light of memories of Licata.

But the serene radiance suddenly disappeared from her ecstatic eyes at the all-too-familiar voice, which was now sharper and lower than usual.

Following her sister-in-law into the dining room, her step was light and dreamy like that of the bride.

"You're ridiculous!" exclaimed her sister-in-law. "You're a foolish old woman! Aren't you ashamed? Get the dessert wine ready and bring it down."

She didn't say: "Don't come," but Bobò didn't go back in, just as if Angela had ordered her not to. She prepared the trays and called the servant to bring them into the living room.

"First the glasses, then the sweets . . ."

She went to her room and took off the cinnamon-colored dress so she wouldn't be tempted to go back down. She felt that she couldn't because now, under Angela's sarcastic glare, neither she nor he would ever be able to relive that sweet moment, gone now forever.

She buried her face in her hands but did not cry. Filled with anguish, she saw with exacting clarity her gray life as an aging spinster, still in love.

Caterina's Loom

❦

Il telaio di Caterina

When their mother died, the two sisters suddenly felt like children holding hands in a dark room. Their aunts, partly out of love for their brother and more so out of pity for their nieces, decided to stay on.

Aunt Vanna was the first to say it: "How will I be able to leave Marietta?"

"And me," sighed Aunt Fifi, "how can I abandon Caterina at a moment like this?"

During the long period spent caring in vain for their poor sister-in-law, each one had let herself be carried away by a particular affection.

Caterina and Marietta now clung to one another more than ever. One wouldn't leave the bedroom if the other wasn't feeling well; one would stop speaking if the other knit her brow, assailed by painful memories. They slept in the same room in two little white beds, and they would always call out

to each other as soon as they lay down:

"Caterina!"

"Marietta!"

They wouldn't fall asleep without saying good night like that.

They even resembled one another. Except that Caterina seemed stronger; Marietta was more delicate. For this reason Aunt Vanna paid special attention to her favorite niece. At home everyone understood, and jealousies didn't arise, if at breakfast Marietta had an egg or two while her sister made do with a piece of fruit or a slice of fresh cheese, or if when stepping out into the courtyard, Aunt Vanna followed Marietta with a shawl ready in her hands. She had developed a little cough that refused to go away.

One evening, while walking up to Crocetta for the first time after the two years of mourning, a stranger, possibly from Palermo, followed them.

Aunt Vanna exclaimed, quite pleased, "That bad-mannered fellow is looking at Marietta."

Aunt Fifi declared, laughing, "No, it's Caterina."

Once back home, the two girls exchanged tender confidences.

"You know, I saw him looking at you. . . ."

"To me it seemed he was looking at you. . . ."

"He stopped under the archway. . . ."

"For you. . . ."

They were happy. And while helping the servant make the beds or sewing at the window that still remained half closed, they smiled absentmindedly, each to herself, at the face

of the stranger who had looked at them. When they went out, they saw him again. He clearly liked Marietta, since he now looked at her alone, with bright eyes full of affection. There could be no doubt about it.

Caterina was a little disappointed, but this preference also seemed natural to her given that every special attention on the part of her father and her aunts had always been directed at her more frail sister.

One day, Marietta was coughing more than usual, and Aunt Vanna didn't allow her to go out.

The young girl wept because of it.

"Do you really think I'm sick? How long have I had this stupid cough? I'm so tired of it!"

But Aunt Vanna wouldn't hear of it. So Marietta proposed to her sister: "At least you go out. . . ."

There was a faint tone of annoyance in her voice, but Caterina replied happily,

"What for? I'd rather keep you company."

Neither one feared in the slightest that their cloistered life would begin again. Marietta put herself to bed in Aunt Vanna's room, where there was more air. Dr. Saitta, who had cared for their mother, was called, and the frail girl's new bedroom was kept dark and smelling of turpentine, just as their mother's room had been kept for months.

Caterina, who was only rarely allowed to enter, would stop in the hallway completely dismayed, listening to every sound, taking in every word, begging them to let her sit at her sick sister's side.

It was a repetition of those sad, faraway days, an eternal nightmare that hung in the air and that ended very slowly.

One evening the pungent odor of fresh flowers and lighted candles veiled the scent of turpentine, and through the open windows one could hear the mournful ringing of funeral bells. . . . Like that, little by little, Marietta slipped away.

• • •

Caterina's heart shattered, worse than when her mother had died. She didn't cry. And when the time came for the *consòlo*, and she was there wrapped up shivering in her shawl between her sobbing aunts, she didn't cry, but she wasn't quiet either. She rambled feverishly, with eyes that were distraught and wide open; she spoke as if her sister were still there, in the next room.

The female visitors were appalled, judging her grief insufficient. But her father, from his corner, stared at her worriedly, and as soon as they were able, her aunts whispered to her, squeezing her hand, "Be brave . . . just let it out . . . cry . . . it will be better."

After the three days of official bereavement had passed, the household settled into strict mourning: the windows were shut tightly, with only those that looked onto the courtyard left slightly open. Although it was September, the rooms were soon so cold that the servant prepared the foot-warmers.

Caterina finally did cry, the first time she set foot in the workroom. She wept, seeing herself seated in front of a place that would always remain empty. She sobbed when she found Marietta's sewing in the basket.

Then she composed herself. She went around the house gathering up everything that had belonged to Marietta: every piece of unfinished work that no one would ever take up again; every object, even her purse, her mass book, her thimble. Everywhere things appeared: here an apron that was hanging; there a tortoiseshell comb. In bed her sister used to pull up her hair, making her look like a little girl again.

Every object was a memory; every memory a pang of sorrow. *Their* room turned into a shrine: images of her sister, smiling sweetly from different frames, adorned with chrysanthemums and evergreens.

She refused to change the position of the furniture.

The bed? It needed to stay right where it was. Her aunts had to continue sleeping in the next room, just like "before."

Aunt Fifi timidly approached Aunt Vanna. "She could get frightened if she wakes up. That empty bed . . ."

She heard them. She heard everything with her sensitive hearing.

"Afraid? Afraid of Marietta! Dear, adored Marietta! If only I could see her. Just once."

And climbing into bed she would sigh, "My Marietta . . . soul of my soul . . ."

It pained her heart, calling out to someone who would never respond; and she would fall asleep sobbing under the covers so that Aunt Fifi wouldn't hear her.

She had thought that you just go on and on . . . and it always seems as if something good is going to happen, and that life will last forever, and that everyone needs you; and

then suddenly it all ends—affections, dreams, hopes that seemed so limitless snap, and the life of the person who's left behind returns to its unchangeable course.

In their house, too, like humble, silent servants the old habits returned hardly changed at all. Every now and then a neighbor or relative would drop by to talk about the deceased, rekindling memories in a matter-of-fact fashion.

And in time, Uncle Raimondo started coming back in the evenings to play cards with his brother, like before, games that never ended, when all you heard was a monotonous "you and you," "you and you," whispered by whomever was playing.

Uncle Raimondo was the oracle of the house: no one could make decisions or resolve a family matter without first hearing his opinion; even *don* Tano always submitted to his brother. Yet, in spite of an awareness of his superioirity, he never opened his mouth unless he had something to say. He was nothing like *don* Tano, who so often recounted any insignificant event that had happened in town just to have something to say in front of the women.

"*Cavalier* Dara ordered a piano from out of town. . . ."

No one responded to his voice, which was always somewhat timid.

Caterina, absorbed in her work and caught up in the vague coming and going of a myriad of thoughts, had no desire to break the lethargic silence that enveloped her soul. She even embroidered in the evenings now, portraits to offer up to her sister. On a silk background the color of slate she traced a delicate garland destined to hold one of Marietta's pictures.

At dawn she would set about working, and as soon as she had finished lunch she would go back to see the effect of a bud or a leaf stitched in the morning. Perfecting her craft of embroidering strange flowers in every shade of gray and ash, she lived for these sad, patient works, loved as though they were living things.

Aunt Fifi observed her niece curved over her embroidery hoop. "She's going to end up just like the other one!" said Aunt Vanna. "And all we'll have left are eyes to weep with. Poor Tano . . ."

"If only we could distract her a little. . . . Get her to go out for a bit of fresh air. . . ."

"I'd take her straight out to the countryside."

"On vacation?! And have you thought about what people would say?! It's only been six months since that dear soul . . ."

"Not even six months," repeated Aunt Fifi. "But Caterina won't last like this."

"Raimondo should bring his daughter over!"

And so one evening Uncle Raimondo brought Nenè, who had just returned from the Maria Adelaide Institute. But Nenè was soon bored: she chattered away gossiping, happily at first and then in a more biting tone, while Caterina remained immersed in thought with her hands folded on her lap.

Maybe she wasn't even listening to her.

No, Nenè couldn't feel sorry for that poor cousin of hers.

And yet she came back the next day together with *signora* Teta Picci, an out-of-towner dressed in a long, black velvet jacket that made her look like a man.

"It's the Italian professor's wife," she explained to Aunt Fifi as Aunt Vanna bustled confusedly about the visitor. "She's a little bizarre, but she has a heart as big as the ocean."

Caterina looked at the new arrival with curiosity and diffidence. She had two tufts of gray hair on her forehead and the skinniest hands, which were always moving. She spoke without stopping to catch her breath, answering her own questions; she talked about people she'd met in Milan and seen in Florence, describing places and people with a phrase or an adjective that brought them to life. She interrupted herself to exclaim: "But don't you ever go out? Yes, yes, I know."

Or else, "You should shake yourselves out of it!" But she didn't wait for an answer and continued on with her chattering.

Aunt Fifi noticed that Caterina's curiosity had become almost playful, and she was grateful to this stranger. She wanted to accompany her out, and while Aunt Vanna lit the way on the landing and Nenè went ahead, she followed the guest and clasped both of her hands, imploring, "Please, stop by again . . . we're so alone!"

"I'll come again. I'll come back. . . ."

And the woman hurried out as Aunt Fifi came back up the stairs, clinging to the iron railing and pausing on every step for the weariness that was gnawing at her heart.

• • •

Aunt Fifi was afraid she'd never see the woman again.

"A woman like that," she would exclaim every now and then, "who's from *il Continente*, who's read and traveled, gets

bored with those of us who don't know how to carry on a conversation."

But *signora* Teta did return, without the company of Nenè. Aunt Fifì, who had gone to answer the door, gave her a warm welcome.

"Caterina! Vanna!" she called out.

In the little workroom there was a cheerful shuffling of chairs and animated whispering: "What luck, what luck . . ."

Don Tano was there, too, and brother and sisters looked at *signora* Teta with anxious admiration as if this woman were bringing joy to their Caterina. They didn't feel much like talking, but they tried every manner of ways to show how grateful they were. They offered her coffee and fruit preserves; then Caterina showed her the loom.

Signora Teta was perplexed. "Fine, fine . . ." she said, moving her hands about. "I've never worked at a loom, but I'm familiar with it."

Caterina then led her into the little sitting room, all closed up in the half darkness, where you could detect a heavy odor of mildew and wilted flowers.

In the dim light that passed through an open shutter she pointed out a large, bright portrait that took up an entire wall.

"Do you see? It's the most beautiful. I'm going to make a garland of chrysanthemums for this one, too. But it's going to take some time."

Signora Teta listened, dumbfounded. Then, avoiding looking at the figure in the portrait that seemed to jump out in all its brightness from the surrounding darkness, she exclaimed,

"This is all fine, but isn't this the living room? The room for friends?"

"Yes. And so? There's one in every room."

She then took her into the bedroom to see two other images, hidden by a covering. Pulling the cloth away, she pointed out the garlands without color that had been patiently embroidered.

"Nice, very nice . . ." said *signora* Teta, going back to the workroom.

"You're going to get sick; you can't live like this! You need something else! You must be very young. No?!" and she continued shaking her head with an impatient and unhappy air. "I lost my mother and my sisters, too, and a dear uncle and so many friends. There's a graveyard at the bottom of my heart. But on my heart, no. On my heart I've planted life. I've made myself strong. I thought about getting married. . . . I traveled all over. Youth has its privileges. Mold doesn't stick to what's new but to what's old."

Caterina took exception to those expressions, which offended the memory of her sister and wounded her ears like too many sharp notes. She regretted having shown her works and decided that, tired as she was, she no longer wished to see the intruder.

But *signora* Teta returned the following day and came every day at the same hour, conquering Caterina's diffidence little by little as well as that of Aunt Vanna, which was less obvious.

"When I can make myself useful to someone I'm happy!"

she repeated with enthusiasm. "That way I think less of my own problems!"

She insisted that they take Caterina out. "A nice walk in the sun!"

"You can't be serious. A year hasn't even passed!" said Aunt Vanna, joining her hands.

"All right, not in the sun! In the moonlight! People won't see then. Give me a shawl, too. No one will think that it's *signora* Teta all bundled up in a shawl!"

The old women laughed at the mad proposal. They would never have let their niece go out, much less let her go off alone with a stranger.

And yet one evening they allowed themselves to be persuaded. They had a good laugh and called *don* Tano to show him *signora* Teta in a shawl.

"Go by way of Sinibbio, don't forget!"

"And you, Caterina, don't open your mouth until you're in town. Someone could recognize your voice."

The young girl clutched her companion's arm. Becoming frightened that she might meet up with faces she knew and pulling her shawl up around her eyes when she passed under a streetlamp, she stepped out into the wide street.

The full moon peeked out from behind the poplars, the frogs croaked in the marshes, and in the distance a dog barked.

Spring was in the air. Caterina breathed in deeply.

"You're going to get sick!" repeated *signora* Teta. "Don't you understand that you need to live?"

Caterina seemed to awaken.

"What you need is a good-looking young man!"

"Oh!" exclaimed Caterina, pulling her arm away, almost offended.

She became quiet. But the hour and the place filled her with a searing need to open her heart.

"You see," she murmured, "it seems that at times my heart is gray, that everything around me is gray. You wonder why I know every shade of gray? I don't love the other colors anymore. If I see people dressed in light colors my eyes have to adjust, like they do in bright light. I don't ever think of leaving the dark. It's in my soul. Don't you see our house? Doesn't it seem dark? Everyone runs away. Not even Nenè came back.

"Nenè is right," she started up again. "She gets bored being with me, someone who doesn't know how to talk about anything, who lives in a house full of old people remembering their adored little one. . . ."

"All right," interrupted *signora* Teta. "Girlhood melancholy. . . ."

The impatient exclamation broke the sad spell.

Caterina became silent again, sighing and regretting that she had talked about herself.

But the older woman, whose intention was to distract Caterina, to do her some good at any cost, went straight to her point without worrying about gentle outbursts and sudden obstinate silences.

Every evening she would remove her hat, only to wrap herself up in a shawl and make her charge trot out toward Sinibbio.

"But I don't know why we should have to avoid people like this," she grumbled to Aunt Fifi. "Isn't it enough that I can't breathe in this shawl!"

Then she added: "Your niece is a treasure! But she's sick. If I were a man I'd marry her on the spot and take her traveling through Italy!"

Aunt Fifi smiled.

"Thank you, thank you! She's starting to get better. The evening walks give her more of an appetite at dinner. And she works less at that blessed loom!"

• • •

One day *signora* Teta appeared looking mysterious, signaling that she had something to say in strict secrecy.

As soon as they sent Caterina off to prepare the coffee, the two sisters huddled around *signora* Teta. Nervously fingering the gold chain of her glasses and pushing aside her gray locks, she confided in them.

The old women looked stunned.

"There won't be a better opportunity. He's a serious young man with a lot of promise. His family is from Verona. Look into the Pavonetti family of Verona."

"We have a nephew in the military who's in that area," recalled Aunt Fifi. "We can write to him."

"But a clerk as a husband!" interrupted Aunt Vanna. "A foreigner? She'll be going here and there! . . ."

"She'll see Italy! Or would you rather she vegetate forever in this hovel that's worse than a mushroom? And besides, he

could settle down in Palermo, in Messina, wherever they want. He's going to get ahead. My husband loves him like a son. But he wants to meet her, I'm telling you. She'll understand!"

The old women looked at one another perplexed.

"To meet her! Tell her straight out that a young man wants to . . . put such ideas in her head and then if nothing comes of it?"

"Something will come of it. The young man is serious. Do you think I'd be talking about him like this if I didn't admire him?"

They told *don* Tano, who was very confused.

"Out of love for her . . . certainly! . . . But we have to get Raimondo's advice."

Don Raimondo had met Professor Pavonetti at the casino. Certainly, he was a good match. But it was best to take precautions, to find out about the family.

And *don* Raimondo wrote and wrote again. Soon they were able to confirm that Pavonetti, whose family enjoyed the esteem of everyone in Verona, was an intelligent and honest young man.

And Caterina?

Aunt Vanna talked to Caterina about him.

"You know, he's a good young man . . . it was really lucky . . . even Uncle Raimondo says so."

"But if he's never seen me? If I've never seen him?"

"You'll get to know one another!"

"And where?"

"Where?" No one had thought about that. In the house it

was unthinkable, laughable. If the engagement didn't materialize, how would they explain the visit of a male stranger?

"He could come in the evening, later . . ." proposed Aunt Fifi.

"Like smuggled goods? In our home? Have you lost your mind?"

"What we need is a neutral house," said Uncle Raimondo.

"Exactly," repeated *don* Tano. "A neutral house."

"But . . ." interrupted Aunt Vanna.

"Slow down! Let's take things one at a time," began *don* Raimondo, extending his hands as though he were dodging an invisible obstacle.

"All right. In my house, it wouldn't be so obvious because I often have friends who aren't from around here come to see my stamp collection. I'll invite him over with that excuse. You," he added, turning to his brother, "you'll find some way of showing up here with your daughter. Nenè will be there, and my wife. . . . It will give you a chance to get to know one another. Of course, all of us will act as though we don't know anything. A chance encounter. Then, when he makes his feelings known to *signora* Teta Picci's husband, we'll have to decide."

"There!" sighed Aunt Vanna. "The most intricate questions become child's play in the hands of Raimondo!"

But Caterina was dismayed. She had never left the house except for those few times in the evening with *signora* Teta walking through the fields; she hadn't seen anyone new for a long time . . . and now she was supposed to go to her uncle's

house to meet a man . . . to meet him and then . . . No! No!

Seeing her favorite niece's future in a happy light now, Aunt Fifi insisted. And when *signora* Teta was informed about it she got very excited just like when she felt there was some good to be done.

"You're saying no? You silly little girl! Do you realize that you're going there to meet *the* Pavonetti? It will be as if the others don't know about it. Do you understand? What's more natural than visiting your aunt and uncle? Him? Oh, he'll think you don't know anything. . . . The living room? Yes, why? You can't meet in the living room? What nonsense. . . . Come on now, be good. Start thinking of making yourself beautiful for tomorrow night."

But rather than making herself beautiful, Caterina knelt down and prayed for guidance. Then she prayed to her dead sister, too. The memories loomed up, sad and confused, like faraway voices without echoes, like the smell of wilted roses. She thought that time passes quickly; it passes quickly and always seems the same. And people rush about, too. And someone stops for something beautiful and falls, overtaken by others who move on without looking back. And the dead, oh, how the dead are forgotten! And yet everyone thinks that life will go on forever. Even Marietta had dreamed and waited. And she, Caterina, had sworn that she would never forget her, but over the past few months for the frivolous company of an outsider, she had all but distanced herself from the memory of that poor creature.

But her sister was smiling at her now, sweetly and without

rancor. She saw her again through a veil of tears and murmured. "Do you really forgive me?"

She recalled the face of the stranger who had looked at her sister, as he paused under the archway.

Without a doubt, if she had lived . . .

Now she was answering her with a sad smile: "Live, you who are still alive. Maybe it's the love . . ."

Caterina raised herself from prayer without ever having prayed.

Till tonight, she thought. Her face reddened at her naked thoughts. What a longing for sun and fresh air! Tonight!

Handsome or ugly? Blond or dark haired?

It was someone. Someone who wanted her, who had also looked at Marietta one evening long ago.

It was love, mysterious and powerful, that would call her.

• • •

Aunt Fifi combed the young girl's hair. Then she went to get her good dress, the one they had made for her to wear during the mourning period for her mother.

The skirt was a bit full, the sleeves too short, and the bodice so wide that it made two creases at her shoulders.

"It's not bad," concluded Aunt Vanna.

A hat? Going out for the first time in a hat? She bundled up in her shawl and waited for the clock to strike eight. Her father, with his new overcoat, walked slowly through the hallway. Her aunts spoke in hushed voices.

They were waiting, like someone waiting to leave for a

strange, faraway place. Caterina shivered. In that sad hour she regretted having said yes. She heard the voice of her father. "Let's go."

Her aunts got up slowly, too, so they could accompany them to the door.

• • •

"Come in! Right this way."

"Professor Pavonetti, my wife, my daughter. My brother Gaetano Fàvara, my niece, Caterina Fàvara."

They all sat down in a circle, a bit embarrassed. *Don* Tano looked at his brother as if to say, "Well, you start."

And *don* Raimondo, wise and accommodating, started up the conversation. He found a comfortable position, brushed a stray hair off his knee, and then asked, looking at the box of stamps that had been set out on a small table, "So, you've only been here a short time?"

"Three months."

"I bet you're not fairing too well, since you're used to big cities."

"Thus far, you're right. But I'm hoping things will improve in the future," answered the professor, looking at Caterina.

"And after this, you'll be moving far away?"

"It depends. If I make the move to a high school, I could settle down in Palermo."

And he started talking about exams, contests, titles, and publications, announcing that he was preparing a study on educational reform.

Caterina wasn't listening. She felt the stranger's eyes on her, inspecting her coldly without kindness or indulgence.

She thought about the purpose of the visit and reddened. She saw her long arms in sleeves that were too short; her breasts seemed enormous, her body huge. She felt a kind of shame just being there in that living room, exposed to the gaze of a stranger who was scrutinizing her with the sole purpose of later sharing his opinions with *signora* Teta's husband. Nenè was talking excitedly:

"Palermo? Yes, I lived there for six years. But in a convent, can you just imagine! The Foro Italico? Oh! Go back? I wish! It's all I dream about!"

Caterina suffered less when her cousin was commanding the professor's attention. But when the eyes of that man who had not yet said so much as a word to her returned to rest coldly on her person, anguish and shame took hold of her once more.

Why had she come to play a role in this farce? She felt a deep disgust for herself and for everyone around her. He was supposed to be her fiancé, that man? Why? Just any man, then? Not the one she'd dreamed about on the road going to Sinibbio in the voluptuous warmth of springtime.

No. No.

But then why stay?

They were asking her something.

"No thank you," she answered distractedly, without looking at anyone.

"The professor was asking you if you like to travel."

"Travel?" she repeated, confused and sounding awkward. "I think I would like it. I've never traveled."

She must have seemed quite clumsy in that insignificant corner of the couch. Could she ever interest that man? No, she would never interest him. She would never interest anyone.

Her head was pounding; it was like going down a bumpy road at night, barely able to see, shaken by the frequent sharp jolts on uneven stones.

How long had she been suffering like this?

She looked at her father to tell him "Let's go!" with a sign.

But her father was completely engrossed, wearing his usual good-natured expression, studying his future son-in-law.

The red of Nenè's smock and the blackness of her hair suddenly struck her. Red and black, black and red filled the room, making her eyes water. She feared she would start crying in front of everyone.

Finally her father turned to her. She made a sign that she wanted to leave.

"Going already?"

"It's late. My sisters are waiting up," murmured *don* Tano, eyeing his daughter anxiously.

No one stopped them.

The cold air that lashed at Caterina's face froze her tears as she walked mechanically, her knees trembling. Father and daughter said nothing to one another. *Don* Tano felt as though he should say nothing. Once home, Caterina became cross when Aunt Fifi asked her a few questions.

She closed herself in her room: she undressed hurriedly, fearing she wouldn't make it in time; she threw herself into her cold little bed with a long shiver, remaining perfectly still, with her face in her pillow, crying disconsolately.

Red and black, black and red, Nenè's laugh, Nenè, who knew how to live, was in front of her in the dark, beyond her closed eyelids.

In the kitchen, Aunt Vanna asked her brother: "So how did it go? What is he like?"

"He's nice. It went fine, up to a certain point. Then he started talking with Nenè.

I'm sure he liked Caterina. He was just talking with Nenè to make himself look important. She was very quiet. . . . I think she may have been a little jealous. But we'll see tomorrow. I'd say . . ."

"I'd say," interrupted Aunt Fifì rudely, "that if nothing comes of this, we should take her to the country. Her nerves are exhausted. One mourning period after another. . . . The timing was bad. . . . And then this whole thing was planned poorly. It's no different than if we'd sent her off to the auction. . . . I was right! Do you both want to make her insane?"

But the next morning they didn't talk anymore about going to the country. Caterina woke up serene, tranquil, and sad, yes, as always (she was that way by nature), a little pale, yes (but she was so delicate!).

Aunt Fifì began, rather encouraged: "Your father said that the professor . . ."

"Listen, Auntie," began Caterina very calmly, "the biggest

favor you can do for me is not talk about him. I don't like him."

"Oh! Why? Your father . . ."

"He's ugly. . . . And besides, he has these ears. . . ." she added, in order to justify herself. "I don't have the courage to tell *signora* Teta. Will you do it for me? Tell her whatever you want."

Out of impatience, *signora* Teta suddenly showed up earlier than usual. "And Caterina?"

"She's in her room. She'll be coming shortly."

"It didn't go too well yesterday evening. But perhaps . . ."

Aunt Vanna, unprepared, blushed. Aunt Fifi explained timidly. "She didn't like him."

"She didn't like him?"

"No . . . he's ugly. . . . He has big ears. . . ."

"She's turning down a match like that because his ears are big? It's childish! Instead of jumping at the opportunity!"

She looked around indignant, piqued, and after a minute took her leave.

She cut back on her visits after that and in time, little by little, she stopped coming by altogether, having lost all respect for a girl who pays attention to a fiancé's ears. . . .

Try helping some people!

Caterina returned to her loom; somewhat listlessly, she began to embroider the frame intended for the large portrait of Marietta.

It didn't shock her when she heard that Nenè was engaged to Professor Pavonetti. She didn't complain that her days had

returned to what they were before, and she found it natural that even *signora* Teta had ended up getting bored with her.

Since a year of mourning had passed and the autumn evenings were beautiful, to make Aunt Fifi happy she started going out with her father after dinner. They walked toward Sinibbio just to get some fresh air.

Next to her father, who kept silent, pushing along little pebbles with his cane, Caterina walked in the wide, deserted road, neither getting too bored nor enjoying herself, following her placid thoughts, looking back with regret on her sweet dream, dead like her mother, dead like Marietta, while time passes quickly and those who know how to live hurry on, never looking back.

Glossary

꧁꧂

barone: a title used to address male aristocrats and nobles
baronessa: a title used to address female aristocrats or the
 wives of aristocrats
case basse: low, street-level houses
cavaliere: a title of distinction generally conferred in one's
 place of work
ciancianedda: in Sicilian, a small tinkling bell
civili: members of the "civilized" or upper class
comare: godmother; also an expression of affection or
 friendship used among equals in the lower classes
compare: godfather; also an expression of affection or
 friendship used among equals in the lower classes
consòlo: in Sicily and other parts of southern Italy, the three-
 to eight-day requisite mourning period during which
 visitors offered condolences in the home of the deceased
continente: Sicilians used the term *il Continente* to refer to

continental Italy. Likewise, the term *continentali* referred to non-Sicilians, whether Italians or foreigners. Both underscored Sicily's sense of isolation and suspicion of outsiders.

corredo: a woman's trousseau consisting of hand-sewn, embroidered, and lace items, including delicate undergarments, bed linens, and table linens

destino: fate; destiny

don: a title of respect, generally used to address male professionals and landowners

donna: a title used to address wives of professionals and landowners

galantuomini: gentlemen property owners, usually referred to with the title, *don*

gna': Sicilian form of address equivalent to *signora* or missus used when speaking to or about women of the lower classes

lira (plural *lire*): basic monetary unit of Italy used until 2002

la Mèrica: the United States. Italian emigration to South America preceded that to the United States but was severely restricted at the turn of the century due to outbreaks of yellow fever in many South American countries. Since most Sicilians emigrated after 1900, any reference to *la Mèrica* (Sicilian for the Italian *l'America*) was understood to be the United States.

marsala: a Sicilian dessert wine

massaro: title used to address well-off farmers or those with multiple tracts of land

mastro: a title used to address artisans such as shoemakers, cabinet makers, tailors, and weavers

mortadella: a steamed and cured pork sausage

moscadella: a variant of the Muscat grape used to make dessert wine

onza (plural *onze*): a Sicilian currency no longer in circulation, coined originally in gold and then silver. At the time of Italian unification, 1 Sicilian *onza* equaled 12.75 *lire*. The average salary of a day laborer rarely exceeded 50 *onze* yearly.

orbace: a coarse impermeable wool, traditionally dyed black, whose weight made it notoriously difficult for seamstresses to handle

paese: literally "country," but also used to refer specifically to one's village or place of birth

pastina: the smallest form of pasta, generally added to broth

prosciutto: either cooked or salted and cured ham

quota (plural *quote*): a small tract of land

savoiardi: ladyfingers

scappularu (plural *scappulari*): a Sicilian term for the heavy, hooded cape worn by shepherds in harsh weather conditions

signora: Italian equivalent of missus

signore: Italian equivalent of mister

ssù: a Sicilian term for *signore* or mister used when addressing laborers or men of the lower classes

verismo: a literary movement in late-nineteenth-century Italy that promoted realist fiction

verista (plural *veristi*): a writer of *verismo*

Afterword

❧

In his lifelong quest to better understand the Sicilian people, Leonardo Sciascia concluded: "It is better to trust literature, to trust the writers who have represented [Sicilian] life and essence, in the mutability of its reality and variety of its characters. For Sicily, that means Verga, Capuana, De Roberto, Pirandello, Brancati, Tomasi di Lampedusa, Bonaviri, Consolo, to name only a few in a rich, intense, coherent tradition" (Sciascia 1991, 3: 522). Sciascia's rediscovery of Maria Messina's writings in 1981 ended her fifty years of literary obscurity and added a new dimension to this male-dominated canon, opening the door for a discussion of Sicilian reality from a distinctly female perspective. Since most of Messina's works, published between 1909 and 1928, portray provincial Sicilian life with a particular focus on women's lives, their recovery has generated considerable interest among proponents of women's writing in Italy. But we must remember that although Messina

denounces treatment of women in Sicily, her love for Sicily and her powerful identification with what she herself termed *la mia sicilianità* (my sense of being Sicilian) endure.

Understanding Messina's views, as well as reconstructing her life, have been challenging tasks for scholars. What was presumably a substantial literary archive (Messina never married and dedicated her life to writing) was destroyed in the Allied bombing of Pistoia shortly before the author's death in 1944. Messina left no critical writing, nor did she produce a personal memoir or autobiographical novel, as did her better-known female contemporaries Sibilla Aleramo, Neera, Grazia Deledda, and Ada Negri (Zambon 1989). Only twenty-three surviving letters to Giovanni Verga, discovered in 1979, and information gleaned from interviews with her late niece, Annie Messina, provide a loose chronology within which to examine the events and influences that shaped the direction of her writing.

Maria Messina was born in Palermo on March 14, 1887, to a schoolteacher and a young woman from the petty nobility. The hastily arranged marriage of her parents was troubled from the outset due to marked differences in their ages and social backgrounds. Messina's aristocratic mother, only sixteen at the time of her marriage, was ill prepared for the responsibilities of domestic life, while her father, embittered at having to abandon his studies, remained a distant figure to his family for many years (A. Messina 1988, 12). Tensions between Messina's parents would subside as the family's economic situation improved, but their two children suffered from the marital disharmony. The close rapport Messina shared with her

elder brother Salvatore, to whom she dedicated her first work, was most likely forged at this difficult time in their lives (Garra Agosta 1979, 28; 33).

In 1903 Messina's father was promoted to scholastic inspector, and the family relocated to Mistretta, a picturesque town sixty miles from Sicily's capital city of Palermo. While Messina nurtured a deep affection for *i buoni Mistrettesi* (the good people of Mistretta), she was deeply conflicted about provincial life as a whole. Coming of age in a milieu that offered young women few opportunities for social interaction was a particularly lonely experience for the sheltered adolescent (Messina 1919, 158).[1] According to her niece, Messina turned to writing as an escape not only from familial discord but also the excruciating tedium of small-town life.

> In those days in Sicily, the male child could escape suffocating provincial life if he wanted. He could study, go out with his friends and sow his wild oats, then there was the university, and finally a career and independence. But for a young girl, condemned to embroidery and piano lessons, there was no other hope than that of a marriage arranged by relatives, or if she was lucky, one that blossomed at family reunions and parties that were strictly monitored by her parents. In that joyless house, where all economic difficulties had to be decorously concealed, even this was lacking. (A. Messina 1988, 12)[2]

No record exists of the years Messina spent in Mistretta or of the events that led to the publication of her first collection of stories in 1909 by the Palermo editor, Remo Sandron. What we do know is that Messina took the extraordinary step of sending the volume, *Pettini-fini e altre novelle* (Fine Combs and Other Short Stories) to Giovanni Verga, the aging master of Italian *verismo*. Although Verga and Messina were both Sicilians who saw in their island's impoverished peasant world a subject worthy of literary attention, Messina's bold move was not without risk. Verga was a towering figure on the literary landscape, a taciturn individual protective of his privacy and reputedly dismissive of women writers.[3] Verga's favorable response to the work was extraordinary recognition for the novice and marked the beginning of a correspondence that would last ten years, until shortly before Verga's death in 1922. In her reply to Italy's most esteemed man of letters, an astonished Messina wrote:

> When I sent you my first book, I had hoped that you would read it, but never did I dare to dream for your opinion on the work. I started out with so much hesitation, and so alone that I feared my poor peasants— studied at length and with so much love, put forth in a "book" and set free to go their own way—would be judged poorly, maybe even barely noticed, and not at all understood in the way I had intended. (Garra Agosta 1979, 27)

Messina's apprehension was understandable. Just twenty-two years old, she was an unknown female attempting to break into the established ranks of her famous compatriots who had long since made their mark on Italian *verismo*. Verga, along with Luigi Capuana, Luigi Pirandello, and Federico De Roberto, were respected authors and university-educated men from affluent families who moved comfortably within the literary circles of Milan, Rome, and Florence. Conversely, Messina was a young woman without formal education who had mastered Italian only through assiduous self-study. While a lack of institutional schooling was not unusual for Italian women writers of the period (and here one thinks primarily of Nobel Prize laureate Sardinian Grazia Deledda) it was nonetheless a formidable obstacle for women like Messina who aspired to literary careers.

Messina's geographic isolation cannot be underestimated, especially when measured against the more worldly experiences of her elder female contemporaries living and writing on the Italian continent. Matilda Serao in urban Naples, Ada Negri in the rural provinces of the North, and even Grazia Deledda, who had left Sardinia for Rome in 1900, all witnessed the rapid expansion of an entrepreneurial middle class and burgeoning proletarian movements in which Italian women had become visible members.[4] Sicily, by contrast, was a region still lacking the basic infrastructures of a modernized society, an insular world dominated by conservative ideologies and removed from the Italian mainstream. Italian women may have lagged far behind their European counterparts in matters

of social and political autonomy at the turn of the century, but for Sicilian women, the situation was magnified to an extreme. In her introductory letter to Verga, Messina speaks—in unusually candid terms for a Sicilian woman of her station and upbringing—of the overwhelming isolation and resulting solitude that defined her formative years:

> I have always lived alone with just my close family; I have never even attended school. My teachers were my mother, when I was little, and then my only and beloved brother, until just a few years ago. . . . Yes, I have grown up alone. And yet I have never really felt the need for others, having always been rather uncultivated and removed from life. Still, I have never ceased to observe life. (28)

This awareness of her position at the geographic, intellectual, and cultural margins of a larger Italian society explains in part Messina's deep feeling of kinship with Verga, not only as an artist she revered, but also as an individual with whom she shared a profound sense of *sicilianità* (43).

Although *verismo*'s influence as a literary movement had waned by the first decade of the new century, Messina was nonetheless inspired by Verga's humble characters, deemed unworthy as literary subjects for previous generations of Italian writers. Her first studies were those individuals she encountered daily within the confines of the family home or immediate neighborhood, "the washerwoman, the peasant who came

from the countryside to sell his produce, the servant girl who helped her mother with the domestic chores" (A. Messina 1988, 12). Giuseppe Antonio Borgese, one of the earliest and most discerning critics of Messina's work, refers admiringly to the young author as "a student of Verga" (Borgese 1923, 164), a compliment that was likely a source of tremendous pride for the aspiring writer.[5] The inevitable, if at times misleading, association with Verga is borne out in the themes, characters, language, and overall style of her first collection, as well as in titles that reflect the fundamentally indifferent and cruel nature of the peasant world. "Janni lo storpio" (Janni the Cripple) is a boy with a debilitating limp; "Solo pane" (Just Bread) an epileptic who begs, asking only for bread; "Pettini-fini" (Fine Combs) a carter who peddles mirrors, combs, and other trinkets to neighborhood women, while his wife carries on with the local *don*. The prevailing image of Sicily is that of a world far removed from the rhythms and sensibilities of modern life, where passions at their most basic level—infidelity, jealousy, revenge, and the longing for material possessions—clash with ingrained Christian teachings of suffering and resignation.

Even in these early attempts, Messina demonstrated an exceptional ability to apply the rigorous dictates of Italian *verismo*, putting herself "under the skin" of her characters as Verga himself had done, "seeing with their eyes and speaking with their words." The seeming ease Messina brought to the execution of her art belied her inexperience, a fact that did not pass unnoticed by the discriminating Borgese who noted: "The results Verga achieved only through lengthy and painful

discipline, Messina arrives at almost naturally, working comfortably, never worrying about setting her sights elsewhere, so convinced is she of their truth" (Borgese 1923, 166). While Borgese's comments were not intended as an artistic comparison between the undisputed master of *verismo* and his protégé, they highlight an essential difference in the sociological perspectives of the two authors. Verga was a writer who had observed the peasants and fishermen he sought to portray from a comfortable distance, a Sicilian bourgeois who drew on the memories of his youth for inspiration. Known to consult the works of Sicilian ethnographer Giuseppe Pitrè, Verga was more of a literary artist than a chronicler of Sicilian life. Messina, on the other hand, lived among her subjects in the tight confines of Mistretta during the formative years of her writing career. This immediacy with the world she depicts accounts for the fine details that round out her portraits of peasant life and differentiates her early work from Verga's highly polished literary construct.

Messina's proximity to her subject matter, coupled with her profound empathy for the most marginalized in her society, allowed her to observe how abject poverty manifests itself in behavior that tests the limits of human tolerance. Grace, the eponymous protagonist of the short story, is clearly fashioned from the larger cast of Verga's *vinti* (vanquished), impoverished Sicilians resigned to the immutable course of their lives. Yet with this first fully developed female protagonist, a new direction in Messina's writing already begins to emerge. Notwithstanding her professed belief in *verismo*'s precept of authorial

impartiality ("An artist must never reveal the measure of his or her own emotion, but rather allow the reader to feel the beauty, the horror, the pain, through the work itself" [Messina 1919, 158]), Messina's view of Grace's pitiful drama is colored by her own experience. It is this gendered perspective that leads Messina to stray from the path of pure objectivity and to examine more closely the root causes of Grace's suffering. In doing so, Messina naturally questions literary representations of female cultural extremes found in some her mentor's most memorable works (Magistro 1996).[6]

Ironically, Grace possesses neither grace nor beauty. She is "quarrelsome and loud by nature," and her emaciated body contrasts sharply with that of her foil, the very sexual la Mottese. Her dehumanization (she is alternately "a begging dog" and "an ugly monkey") results not only from her degraded condition, but also from brutal physical abuse at the hands of her lover, Gemello. Although Grace may vent, she is ultimately silenced by the terrifying realization that rebellion is futile, that others have defined her and thus control her future. In the end she ceases to reflect and no longer rails against the injustices perpetrated against her—not unlike the acquiescing protagonists of Messina's later narratives who endure similar emotional anguish but no measure of Grace's physical deprivation.

Pettini-fini (Fine Combs) was published the year Messina's family left Sicily in the first of many moves that would take the author to Ascoli Piceno, Arezzo, Naples, Florence, and finally Pistoia. The critical success of *Pettini fini* and *Piccoli gorghi*

(Small Vortexes) which followed in 1911, established Messina as a literary voice in the growing arena of women writers who had emerged in Italy over the last quarter of the nineteenth and first decade of the twentieth century. Between 1909 and 1928, her works appeared in Italy's prestigious literary journal *Nuova Antologia*, as well as in the widely read women's publication *La donna*. In addition to her receiving the singular endorsement of Verga, the distinguished publishing houses of Treves, Sandron, Vallardi, Le Monnier, and Bemporad published her major works. Messina also produced a vast body of work for children that appeared regularly in Italy's *Corriere dei piccoli*, a journal dedicated to children's literature.

In spite of an auspicious beginning, attaining the literary recognition accorded her female contemporaries proved difficult for Messina. The author's letters allude to her family's frequent moves as well as to bouts of ill health that may have precluded a more visible presence on the literary scene. However, the correspondence with Verga also suggests that Messina continued to lead the essentially insulated life of a proper Sicilian woman long after she had relocated to the Continent, residing with her parents until their respective deaths and dedicating herself solely to writing. Unlike Deledda, Aleramo, Serao, and Neera, writers who were vocal in their support or condemnation of feminist causes, Messina did not engage in this public debate nor did she proffer opinions in articles that addressed pressing women's issues. Rather, ongoing struggles with publishers consumed her energies. Writing to Verga in 1913, a disillusioned Messina confided: "The little author of *Pettini-fini* is now very familiar

with the harsh and painful path she has embarked upon . . . a road that has sharpened her spirit and stripped it of every beautiful illusion" (Garra Agosta 1979, 37). Verga's declining health in the years preceding his death had left Messina without a close ally to intercede on her behalf in Italy's competitive literary market. Sustained at times only by the memory of Verga's encouragement, her own inborn tenacity, and a belief in the superiority of her mentor's literary model, Messina battled constantly to bring her works to print:

> Those who have disciplined their spirit in the hard school of life, who have worked for years before sending off even a small piece, who aim at a far off and glorious goal, and refuse to content themselves with glittering and momentary little vanities, no, those individuals should not feel dejected if, when taking their first steps, they see the road ahead of them blocked by an onslaught of small minds. Years of easy work followed by years of endless waiting have taught me many things. (Garra Agosta 1979, 38)

Steady if modest success, coupled with the move to continental Italy, afforded Messina opportunities to expand the scope of her subject matter beyond Sicily. Yet, in the three collections of short stories (and two novels) that followed *Piccoli gorghi*, the author remained firmly anchored to her roots, both in her continued adherence to the narrative structures of Italian *verismo* as well as in her choice of Sicily as preferred narrative

terrain. Modern critics of Messina's work have attempted to explain this reluctance to break with *verismo* within the larger context of women's writing in turn-of-the-century Italy (Di Giovanna 1989; Barbarulli and Brandi 1996). Proponents of *verismo* had emphasized ambience, not heredity, as the determining factor in their characters' lives, a belief that resonated with women writers, eager to ameliorate their inferior status in Italian society. The *veristi*'s added refusal to sanction any intrusion into the text by the author protected the public persona of women writers while allowing them "direct access to their own preoccupations" (Kroha 1992, 20). Behind the "invisible hand" of an impartial narrator, women were suddenly at liberty to expose injustices perpetrated against them without fear of reprisal. The argument would seem to carry additional weight for such writers as Messina and Deledda, given the extreme degree of patriarchal control in their societies and the very real prospect for retaliation against women who aimed beyond traditional roles.[7]

In Messina's case, however, this unwavering commitment to the principles of *verismo* appears more closely aligned with her unshakable belief in Verga's artistic vision ("I have always looked toward that purest light that emanates from the greatest of all teachers" [Garra Agosta 1979, 45]) and in an abiding, albeit conflicted sentiment for her homeland. In a provocative hypothesis that speaks directly to Messina's experience, one of Sicily's most perceptive critics, Leonardo Sciascia, maintains that writers born in Sicily are "bound to the representations of a Sicilian reality," and especially those who find themselves in

the position of the exile (Sciascia 1991, 1; 961–67; Sciascia 1991, 3; 519–24). Messina, as we have noted, lived for many years in Tuscany, discovering there the ideal of civilized life that had eluded her in Sicily (A. Messina, 1998). Three of her later novels are at least partially set in the region. Yet, it was Sicily that left its mark on her spirit and inspired her finest works, a phenomenon Sciascia finds curiously singular to all Sicilian writers separated from their native land: "In some, this condition expresses itself in painful memory, in nostalgia, or in a mixture of the two. In others, it is the desire to forget, or intolerance, or rancour. All, however, have felt dramatically or with aching anxiety, the essence of being Sicilian, of partaking in a reality, a manner of being, a human condition, that is distinct and irreversible. And more or less consciously, and more or less freely, they have accepted the sentence of representing that reality, that manner of being, that human condition" (Sciascia, 1967, ix).[8]

Messina's letters to Verga are replete with soulful references to her homeland and its people, evidence that separation from all things familiar went beyond mere nostalgia in the vein that Sciascia suggests:

My sense of being Sicilian has been fed by the deepest roots of my soul: *sicilianità* of race, birth, and sentiment of which I am proud. . . . My father is a scholastic inspector; in bureaucratic terms, he is "subject to transfers." We are like birds without a nest. . . . I have not been to Sicily for four years, and I long for the air

that has nurtured my spirit. Will I ever again return to
the villages of my Sicily? (Garra Agosta 1979, 50–51)

The depth of such emotion might well explain the atten-
tion Messina dedicates to the emigrant experience in *Piccoli
gorghi* (Small Vortexes), published two year after leaving Sicily,
but conceived in part while the author was still living on the
island.[9] Messina's visceral attachment to Sicily and the sense of
displacement she experienced in the years following her depar-
ture find an emotionally powerful outlet in her portraits of emi-
grants and their families. While these moving stories reveal
Messina's affinity for the uprooted emigrant on a very personal
level, they are also significant for the position they occupy in
the larger canon of Italian emigration literature.

The question of why a subject so rich in raw thematic
material was virtually ignored by Italy's finest writers in the
heyday of Italian realism points to an omission that scholars
have only recently begun to address (Franzina 1996; Marazzi
2004).[10] Sciascia was among the first to raise the issue in his
introduction to *Partono i bastimenti* (The Steamships Are
Leaving), a commemorative volume on emigration that rein-
troduced Maria Messina to the Italian reading public. Fram-
ing the argument within Italy's broader historical neglect of
the Italian South ("It is strange that such a human drama, and
especially as it occurred in the South, with its overflowing
numbers of emigrants, would be given such scarce, bare-bones
attention" [Sciascia 1980, 8]), Sciascia praises Messina, an
unknown writer, for her remarkable vision.

Whether Messina intuited the significance of the unprec-
edented phenomenon or was simply eager to pursue her craft
of "art rooted in the study of life" remains unclear. What we
do know is that the author wrote often and poignantly of the
experience, making it the centerpiece of four short stories and
one full-length novel for children. Messina was the only
author, as well as the only woman of her day, excluding writers
of memoirs, to have dealt with the subject in such a compre-
hensive manner. Emigration historian Emilio Franzina singles
Messina out for the unusual artistry of her narratives that
"express a more mature variation of the generic mourning" as
well as for her original handling of "themes of madness and
death more subtly connected to the exodus and its effects"
(1996, 147).

It was most certainly by design rather than chance that
Messina chose the identical title, "*La Mèrica*," for two short
stories that examine different aspects of the emigrant experi-
ence: the first of hopeful departure, the second of devastating
return. A third work, "Nonna Lidda" ("Grandmother Lidda")
deals with the plight of the elderly, most of whom were left
behind either because of financial considerations or bureau-
cratic regulations, while a fourth, "Le scarpette" ("Dainty
Shoes") recounts the trials of a determined shoemaker who
returns sobered by his experience. Taken as a whole, the sto-
ries highlight the most salient features of the phenomenon and
reveal the human toll emigration exacted on Sicily's people.
Although the author challenges some stereotypes that pre-
vailed in circles hostile to southern Italian emigrants (Mariano

and his wife may be peasants, but they are neither starving nor illiterate), she predictably sees little positive in the experience. The new world is alternately conceived as a "seductress" and a "woodworm" that ravages family structure and threatens to permanently alter life in the traditional Italian South. The author's sensibilities account for her focus not on success stories typical in much of the early production of the genre (Harney 1978, 65), but on unsuspecting victims caught in a moment of unprecedented historic transition (Alba 1985, 38–40).

With their attention to detail, these deceptively simple works belie the importance of familial relationships and social hierarchies that defined Sicilian society and that figured centrally in the decision to emigrate. The themes Messina weaves into the fabric of her narratives, long the focus of historians and sociologists, explore the relationship of the male émigré to his family during his sojourn abroad, the effects of emigration on wives left behind, the mental and physical deterioration of the returnee, and the inability of the emigrant to readjust to the life he once knew. Along with these undercurrents in her writing, Messina skillfully chronicles her society's beliefs, fears, and historic distrust of outsiders, humanizing the masses that crowded the teeming ports of Palermo and Naples at the turn of the past century. Whether conveying a peasant's disorientation, a young woman's reluctance to submit to a medical exam, the terrifying signs of progressive trachoma (the most dreaded of all eye diseases known to the emigrant), or the anguish and angst of the abandoned elderly, Messina gives readers a cultural framework in which to understand the Sicilian emigrant experience.

While Messina tells these stories from a female perspective and assumes the primacy of female characters, her sympathies extend across the gender divide to encompass all those affected negatively by the phenomenon. Venera's abusive husband, Petrù, returns home after eight years, broken by physical labor and psychologically traumatized by the experience. Petrù's failure to return a truly rich man, while provoking the silent scorn of his wife, is not the overriding source of his torment. Rather, it is the radical reversal of their traditional lives, the fact that he has been supplanted as a breadwinner by Venera "who ran the store better than a man" that so demoralizes Petrù. As the shop flourishes under the careful watch of his wife, the protagonist withdraws from all that was once familiar ("He was as alone in his own village as he'd been in the immense American city"). Unable to reverse the downward spiral of his mental and physical decline, Petrù is ultimately consumed in one of Messina's emblematic "small vortexes" that destroy those ill prepared to deal with change.

Although Messina dedicated *Piccoli gorghi* to Verga, the collection as a whole signals the author's desire to stake out new territory and move beyond representations of Sicily's peasant world. Looking back on the early years of her career, Messina recognized the inevitability of this course, wryly noting: "Anyone looking to describe the world depicted by Giovanni Verga might as well have been searching for a bunch of grapes in a freshly harvested vineyard" (Messina 1929, 62). The focus on Sicily's petite bourgeoisie, a class obsessed by appearances and social decorum, was by no means a novel direction for Sicilian

writers in 1911. Emanuele Navarro della Miraglia had favored the subject some thirty years earlier in *La nana* (1879) and *Storielle siciliane* (1885), as had Verga in his masterpiece, *Mastro-don Gesualdo* (1888). Provincial life also serves as the backdrop for a number of Luigi Pirandello's early stories written in the 1890s (later published in *Novelle per un anno* [1952]), as well as for his novel *L'esclusa* (*The Outcast* [1908]), all works that find parallels in Messina's mature narratives (Sciascia 1981, 61).

The originality Messina brings to the subject of provincial life derives not only from her feminist perspective and penchant for the psychological, but from her ability to interpret— "always in a minor tone," according to Borgese—the chronic ills of her society: "What torments is the unrelenting and lingering poverty, found more or less in equal proportion in the houses of the peasants and those of the lower middle class, perhaps worse in the latter where the sense of responsibility is more piercing, where it is more difficult to adapt oneself to living day to day, and where one would almost prefer hunger to shame" (Borgese 1923, 167).

"Ti–nesciu" ("I Take You Out"), aptly titled in Sicilian for its pointed portrayal of provincial life, reaffirms Borgese's critique and sheds light on Messina's conflicted views about her traditional society. The author leaves little doubt that the reckless behavior of the widowed Scialabba has compromised his daughter's future and thrown the pair's financial situation into uncertainty. But Messina also goes to great lengths to paint the aging lawyer not as a domineering patriarch, but as an unwitting victim of his own slavishness to propriety. "With his frayed but

sparkling white collar" and desire to be perceived as a gentleman (as in his habit "of always speaking Italian with his daughter and the peasants"), the mild-mannered Scialabba cuts a decorous and benevolent figure. Messina would almost have us forget that he is a man so wholly consumed by personal honor that he has been blinded to his daughter's suffering.

The evening walks of father and daughter underscore the relentless monotony of provincial existence; the silence the two share, a tacit recognition of the emptiness that defines their lives. The author's empathy for the tormented Liboria is barely concealable in the secretly commissioned sale of her *corredo*. Yet, the anguish of the scene is surpassed in the wrenching, quasi-grotesque depictions of father and daughter who respond instinctively to the demands of class. Stoic in the face of ridicule, Scialabba and Liboria faithfully don their Pirandellian masks each evening to participate in the ritual Sicilian promenade: "It was necessary to be seen."

As Messina moves in the direction of psychological narratives that explore the oppressive nature of women's lives (a reality with which she was intimately familiar), she increasingly lends her own consciousness to her characters. Turning her artistic lens onto the penury of her own class and into respectable houses where young women languish behind closed doors, the author exposes the implications of Sicily's unshakable economic laws on those "too polite to speak out; too weak to rebel." Messina understood well the economic forces that fostered the control of women in her society and the mechanisms designed to enforce them. Her own parents' unhappy

marriage was the result of such interference (A. Messina 1988, 12). The frequency with which arranged marriage, spinster-hood, and similar themes appear in the collections *Le briciole del destino* (The Crumbs of Destiny [1918]), *Il guinzaglio* (The Leash [1921]), and *Ragazze siciliane* (Sicilian Girls [1921]) testifies that there was still ample room on the canvas of Italian *verismo* for additional paint long after it had exhausted itself as a literary movement (Baldini 1918).

Taken as a complex whole, Messina's short stories (as opposed to her novels set outside Sicily) may be read not only as complex commentaries on the lives of Sicilian women, but also as a continuous "counter history" to women's lives in other Western cultures. Viewed in this light, Messina's work is again curiously and characteristically Sicilian. The island's resistance to change—its tragically missed appointment with history—is a theme that finds a consistent and efficacious vein in the larger body of Sicilian literature from Verga to Consolo (Onofri 2003). By way of parallel in Messina's narratives, this same historic immobility and the immutability of economic laws are mirrored in the static nature of women's lives.

Unfaltering adherence to behavioral codes inevitably seals the fates of Messina's characters. Bobò renounces love and surrenders to the wishes of an avaricious brother; Vanna ini-tially submits to the will of a family who forces her return to a husband she does not love; Caterina subjects herself to the humiliation of the "marriage market" in order to please her aunts and father. When the exercise of free will collides with paternal authority, Messina's protagonists subvert their desires

and bow to the interests of family, even when such interests are exposed as hypocritical and motivated by self-interest. Most disturbing, yet most predictable is that the great majority of Messina's protagonists perceive their sacrifice as necessary for the family's collective welfare and are thus incapable of viewing themselves as victims.

In "Casa paterna" ("Her Father's House"), the family is no longer the nurturing refuge envisioned by Verga but rather a menacing instrument of coercion, its members more preoccupied with decorum than with the well-being of a loving daughter. Vanna's "rash" action has undermined her husband's undisputed authority, compromised the honor of her family, and threatened the future marital prospects of her younger sister. Through her use of irony (Vanna's mother "had failed to inculcate in her daughter those sentiments of submission and sacrifice that are a woman's principle virtue"), Messina condemns the lack of autonomy accorded Sicilian women and makes a powerful statement regarding male "ownership" that is reminiscent of Sibilla Alermo's *Una donna* (*A Woman* [1906]) and Grazia Deledda's "Battesimi" ("Baptisms" [1926]). Vanna's presumed death by suicide constitutes a rare step for a Messina protagonist—both a silent protest against the demeaning alternatives she faces as well as a symbolic exercise of the free will denied her: "the choice of death over life when life has become little more than a deathlike existence" (Magistro 1996, 117).

With no outlets for self-expression, Messina's protagonists necessarily lead intense inner lives. Dreams of marriage and motherhood, the only socially sanctioned avenues open for self-

realization, are fueled by repressed or unfulfilled emotional and physical desires. When such hopes fail to materialize or when they are thwarted by the actions of others, these women face the terrifying prospect of spinsterhood, with its endless succession of days and excruciating routine. Time, which "changes the color of things," transforms them, cruelly leaving their "virgin hearts intact."

The degree to which Messina's protagonists internalize behavioral expectations also manifests itself in their unfailing, at times baffling, silences and is stylistically rendered in narratives that are riddled with ellipses, unfinished sentences, and internal monologues. Clearly, Messina had learned her lessons well from the exacting Verga, an author who insisted that all writers create for themselves a language perfectly suitable to the world of their characters. Drawing on her experience as well as on her careful observations of daily life as it unfolded within her own class, Messina settles on the language of silence, as the absence of any meaningful voice was the most accurate measure of Sicilian female existence (Barbarulli and Brandi 1996).

This persistent social aphasia afflicts all Messina's protagonists and finds its highest expression in the character Ciancianedda, a young girl who has literally lost her voice. Struck by a mysterious fever that has left her unable to speak or hear, Ciancianedda inhabits a world bound by fearful silences. The freedom she enjoyed as a child, epitomized in her unfettered singing, stands juxtaposed to the "leaden silence that weighs heavily on her heart and ears" once she has entered the world of

female adulthood. Unable to articulate the feelings she longs to express ("the words were suffocating her") and equally shut out from any reciprocity ("nothing linked two creatures together like the spoken word"), the betrayed Ciancianedda is reduced to observing life from behind the grate of her closed door, left to wonder, like Vanna, "if there is a place in the world" for her.

In a penetrating and comprehensive critique of Messina's work that underscores its artistic merits, Maria Di Giovanna analyzes the recurring lexicon Messina uses as a corollary to these silences (1989). Arguing for a unifying structure she terms *il luogo chiuso* (closed space), Di Giovanna systematically traces the spatial imagery of confinement in Messina's narratives set in Sicily. The psychological and physical isolation of women is mirrored in the restricted space of domestic interiors, suffocating atmospheres replete with faded furnishings, shadowy parlors, drawn shades, and shuttered windows. The outside, natural world—Sicily's sweeping landscapes and ever-present sea—stands diametrically opposed to the colorless landscape women inhabit. A tangible symbol of the freedom denied them, it is a space relegated to memory, the lone refuge for Messina's lonely protagonists. Ironically, this escape from an unhappy present into an idyllic past inevitably takes the shape of a return to the *casa paterna*, remembered not as oppressive closed space (*il luogo chiuso*) but as a nest or protective space (*il nido*), underlining once again the fundamentally unresolved contradictions in Messina's writing.

This type of obsessive and conflicted relationship with Sicily pervades the work of all Sicilian writers. Borgese himself

referred to it as *nec tecum nec sine te vivere possum* (neither with or without you can I live) pervades the works of all Sicilian writers (Sciascia 1991, 3; 524). Rarely is it so apparent than in Messina's "Cogedo" (Parting Words) that concludes *Ragazze siciliane* (Sicilian Girls) (1997b). The convoluted language of the passage is at best ambiguous and devoid of harsh denouncements that might have pointed the way to a new direction in the lives of young Sicilian women. Rather, in what amounts to a veiled apology for the larger body of her work, the eminently feminist Messina expresses a vague solidarity with her defeated protagonists, validating their dreams and elevating their suffering without condemning its fundamental cause.

> Sicilian girls, or I should say Sicilian young women, since in this book we have met neither girls of the lowest classes nor those of the nobility, but rather the daughters of poor clerks and small shopkeepers . . . young women who sew their trousseaux and wait for a love that may never come again, once it has passed their way, or that might present itself in the guise of "a proper match."
>
> Camilla or Bobò, Caterina or Bettina—none live in big Sicilian cities where young women, like their sisters across the sea, prepare themselves for battle.
>
> No. They live in small, far-off, and forgotten towns where habits mark the unchanging rhythm of life, where both novelty and sounds arrive late, like muted voices in the distance. They, too, speak of a

desire for freedom, even though they continue to walk in the well-worn ways of those who have come before them, dreaming of babies to rock and houses to govern . . . humble dreams of which they dare not speak.

Neither Camilla, who "breathes more freely," nor Bettina, anxious to give meaning to her youth, changes her fate—none of them do. And yet in their destinies, there is always a ray of sunshine because each one of these girls, whom pleasure has not deluded with a false laugh or painted lips, believes in "something" and desires to help someone.

And she who believes in the usefulness of her work or in the words of the one who loves her, she who longs for a happiness lost to her because of her own missteps, or who remembers a precious little life that is no more, each one occasionally steps out of that circle of life to enter, alone and unseen, that small, spiritual sanctuary where her convictions and noblest aspirations of femininity remain fresh and untouched. (Messina 1997b)

Messina penned the "Congedo" in 1921 at a moment when her future was uncertain (1997b). Deteriorating health had hampered her ability to write, and frustration regarding the mysterious nature of her illness compounded her dejection during this period. In spite of these obstacles, Messina countered bouts of debilitating inactivity with periods of extraordinary productivity. Between 1920 and 1921 alone, she published

three collections of short stories, *Il guinzaglio* (The Leash), *Ragazze siciliane* (Sicilian Girls), and *Personcine* (Little People) as well as three novels, including her most highly acclaimed work, *La casa nel vicolo* (*The House in the Shadows*), a novel set in Sicily. Eventually diagnosed with multiple sclerosis, Messina published her last novel in 1928 and retired to the Tuscan countryside outside Pistoia where she died from complications of the disease in 1944.

At the time of her death at age fifty-six, Messina had faded from the literary scene, forgotten by editors, critics, and the reading public (Pausini 2001, 183–94).[11] Her name appears nowhere in twentieth-century Italian literary histories, and she remained virtually unknown to the modern literary establishment until the 1979 discovery of her letters to Verga by Giovanni Garra Agosta. Sciascia's subsequent recovery of Messina's writings prompted the republication of three short stories that appeared in 1981 under the title *Casa paterna*. In his brief commentary that accompanies the stories, Sciascia reproached the feminists of his day, questioning how it was possible, in an era "dedicated to the recovery of feminine texts," that scholars had overlooked Messina's work. In fact, Messina's name is conspicuously absent from Giuliana Morandi's *La voce che è in lei* (The Voice Within Her [1980]) one of the seminal studies on lesser-known women's writing in late nineteenth- and early-twentieth-century Italy. At Sciascia's urging, the Palermo publishing house of Elvira Sellerio began reissuing Messina's short-story collections and novels in the 1980s, an effort that continues to this day.[12] Many of the author's numerous works

for children, however, remain out of print and a republication of Messina's complete opus has yet to appear.

Recent scholarship has done much to rescue Messina from literary obscurity, recognizing in her powerful, understated narratives one of the most original voices in early-twentieth-century Italy. The substantial bibliography on the author (Pausini 2001, 169–76), as well as ongoing critical studies by scholars on both sides of the Atlantic, will most certainly ensure Messina a long-denied but well-deserved place in the Italian canon. Messina's works have been translated into French, Spanish, and German, yet only one novel, *La casa nel vicolo* (*The House in the Shadows*), is available in English. This current translation of a small number of her works is a modest beginning and one that will hopefully spur further interest in a writer truly worthy of international recognition.

Notes

All translations from the Italian are my own unless otherwise noted.

1. In a rare, personal testimony that appeared in the Italian literary journal "L'Italia che scrive," Messina reflected on her first two collections, written in part while living in Mistretta: "*Pettini-fini* (Fine Combs) and *Piccoli gorghi* (Small Vortexes) were my inseparable companions as I took my first steps. . . . Concise pages, without adjectives; like the words of someone who lives an inner life intensely, like my own youth tempered by solitude" (Messina 1919, 158).

2. Sicilian novelist Emanuele Navarro della Miraglia elaborates on the details of stifling provincial life in *Storielle siciliane* (1885) and *La nana* (1879). Set in the fictional Sicilian town of Villamaura, *La nana* recounts the clandestine affair between a beautiful woman of the lower class and a

young Sicilian gentleman. Once the affair is discovered, scandal ensues. "No one was really interested in confirming the facts. The important thing was that there was something to chatter about and make fun of in the long hours with nothing to do. How would life differ from the plant world in small, provincial towns if calumny, malicious gossip, and small talk, didn't crop up every now and then to make it more interesting?" (Navarro della Miraglia 1963 [1879], 154–55).

3. In a letter to Paolina Greppi, written in 1890, Verga recounts the incident of a woman who had solicited his opinion on her manuscript: "I read it in good faith, although I must confess to you that I have never had much faith in women writers, or rather in their artistic worth, including Sand who is tiresome and excluding [Matilda] Serao, who succeeds only because she is a hermaphrodite" (Raya 1980, 157). Many in the male literary establishment shared Verga's reservations about the abilities of women writers. Luigi Capuana's disparaging commentary that appeared in *Nuova Antologia* in 1907 is particularly notable.

> I remain convinced that in the future, in the far off future, women will be what men are now. But by then men will have completely changed too, and the distance between them will still be the same as it is today. Then men will leave women the business of writing novels, lyrics, tragedies, comedies, and if they feel like it, poems. However, I must add that they will never succeed in creating anything new because by then, there will be nothing new to create in artistic forms. It will be an eternal repetition until they tire of it, something that is rather improbable. Women are obstinate. (Capuana 1907, 21–22)

4. A nascent feminist movement in the decades following national unification in 1861 brought longstanding women's issues to the forefront of Italian politics. Women's growing presence in the factories of the industrialized North raised awareness about universal suffrage, the inequality of Italy's Civil Code, and the need to regulate working conditions. Activists Anna Maria Mozzoni (1837–1920) and Russian-born Anna Kuliscioff (1857–1925) were two of the most instrumental figures

in the early years of the battle regarding *la questione femminile*. The debate did not enter its most critical phase, however, until the turn of the century (Odorisio 1986).

5. Messina's response to Verga in a letter of 1911 testifies that Verga offered rare words of support to his young protégé: "You have made me weep out of tenderness and gratitude. I am young, oh my teacher, young and timid and your praise fills me with humility. I ask myself, "What have I ever written that merits praise like that from Giovanni Verga? Am I worthy?" (Garra Agosta 1979, 33).

6. Verga's Mena Malavoglia is the proverbial nineteenth-century "domestic angel" who suffers in silence at her loom (Verga 1973, 67), while La Lupa, with her insatiable sexual desire, wreaks destruction on Christian men (1974, 145).

7. In her autobiographical novel *Cosima* (published in English under the same name), Deledda recalls how her first story, published in a women's magazine, sparked outrage in her small town of Nuoro. Reaction on the part of her spinster aunts "who did not know how to read and who burned those sheets with pictures of sinners and evil women" was equally vehement (Deledda 1975, 63). Messina alludes to a similar reality in a number of her fictions, suggesting that her literary ambitions were met with equally harsh criticism: "I was used to my father shouting every time he saw me with a piece of paper, and to my mother always telling me that a girl should cut off her hands before she even thinks about writing down her thoughts" ("Il pozzo e il professore," in Messina 1997c).

8. Joseph Farrell discusses precisely this relationship between Sicily and Sicilian writers within the context of Sciascia's own writing (Farrell 1995, 32–47).

9. The second story entitled *"La Mèrica"* was published as part of the collection *Le briciole del destino* in 1918. However, Messina confirms that she had completed the volume by 1913—just two years after the publication of *Piccoli gorghi* (Garra Agosta 1979, 43)—making the work chronologically closer to her other emigration stories as well as to her own emigrant experience.

10. Some of the most notable contributions to the genre in this early period are those of Sicilian writers. See Luigi Pirandello's "L'altro figlio"

("The Other Son" [1905]) and Luigi Capuana's lesser-known *Gli americani di Ràbbato* (The Americans from Ràbbato [1909]).

11. Messina's last letters, written to the Florentine editor Enrico Bemporard between 1917 and 1926, attest to the author's failing health, financial concerns, and final editorial struggles. The letters were recently published for the first time in Cristina Pausini's *Le "briciole" della letteratura: Le novelle e i romanzi di Maria Messina* (2001).

12. In the late 1990s, Roswitha Schoell-Dombrowski collected five of Messina's previously unpublished short stories. Sellerio published the volume in 1998 under the title *Dopo l'inverno* (After the Winter).

Works Cited

Alba, Richard. 1985. *Italian Americans: Into the Twilight of Ethnicity.* Englewood Cliffs, N.J.: Prentice-Hall.

Baldini, Antonio. 1918. Review of *Le briciole del destino,* in "Rassegna italiana," 15 July.

Barbarulli, Clotilde, and Luciana Brandi. 1996. *I colori del silenzio: Strategie narrative e linguistiche in Maria Messina.* Ferrara: Luciana Tufani Editrice.

Borgese, Giuseppe Antonio. 1923. "Una scolara di Verga." In *La vita e il libro,* 1913. Reprint, vol. 3, Bologna: Zanichelli.

Capuana, Luigi. 1907. "Letteratura femminile." *Nuova Antologia,* 1 January.

Chapman, Charlotte. 1971. *Milocca: A Sicilian Village.* Chicago: Schenkman.

Deledda, Grazia. 1964. *Cosima.* 1937. Reprinted in *Opere scelte.* Vol. 2. Milano: Mondadori.

De Roberto, Federico. 1880. "Documenti umani." Rpt. in *Documenti e prefazioni del romanzo* italiano dell' ottocento. A cura di Renato Bertacchini. 1969 Roma: Stadium.

———. 1929. "Ricordi e aneddoti verghiani." In Studi verghiani. A cura di Lina Perroni. Palermo: Edizioni del Sud.

Di Giovanna, Maria. 1989. *La fuga impossibile. Sulla narrativa di Maria Messina.* Naples: Federico and Ardia.

Farrell, Joseph. 1995. "De Rebus Siculus." Leonardo Sciascia. Edinburgh: Edinburgh University Press.

Franzina, Emilio. 1996. *Dall'Arcadia in America: Attività letteraria ed emigrazione transoceanica in Italia (1850–1940)*. Turin: Edizioni della Fondazione Giovanni Agnelli.

Garra Agosta, Giovanni. 1979. *Un idillio letterario inedito verghiano: Lettere inedite di Maria Messina a Giovanni Verga*. Catania: Greco.

Harney, Robert. 1978. "Men Without Women: Italian Migrants in Canada, 1885–1930." In *The Italian Immigrant Woman in North America*. Ed. by Betty Caroli, Robert Harney, and Lydio Tomasi. Toronto: The Multicultural History Society of Toronto.

Kroha, Lucienne. 1992. *The Woman Writer in Late Nineteenth Century Italy*. Lewiston/Queenston/Lampeter: The Edwin Mellen Press.

Magistro, Elise. 1996. "Narrative Voice and the Regional Experience: Redefining Female Images in the Works of Maria Messina." In *Italian Women Writers from the Renaissance to the Present*. Edited by Maria Ornella Marotti. University Park: Pennsylvania State University Press, 111–28.

Marazzi, Martino. 2004. *Voices of Italian America*. Translated by Ann Goldstein. Madison: Farleigh Dickenson University Press.

Messina, Annie. 1988. Introduction to *Piccoli gorghi*, by Maria Messina. Palermo: Sellerio, 9–15.

———. 1998. "Un ricordo di Annie Messina." " Intervista di Salvatore Intelisano. "L'istrice."

Messina, Maria. 1929. "Inchiesta su Verga." In *Studi verghiani*. Vol. 6. A cura di Lina Perroni. Palermo: Edizione del sud, 62–63.

———. 1996. *Pettini-fini ed altre novelle*. Palermo: R. Sandron. 1909. Reprint. Palermo: Sellerio.

———. 1997a. *Piccoli gorghi*. Palermo: Sandron, 1911. Reprint. Palermo: Sellerio.

———. 1997b. "Congedo." In *Ragazze siciliane*. Firenze: Le Monnier, 1921. Reprint. Palermo: Sellerio.

———. 1997c. *Ragazze siciliane*. Firenze: Le Monnier, 1921. Reprint. Palermo: Sellerio.

———. 1996. *Il guinzaglio*. Milano: Fratelli Treves. 1921. Reprint. Palermo: Sellerio.

————. 1980. *Casa paterna*. Palermo: Sellerio.

————. 1996. *Le briciole del destino*. Milano: Fratelli Treves. 1918. Reprint. Palermo: Sellerio.

————. 1998. *Dopo l'inverno*. Palermo: Sellerio.

————. 1998. *Personcine*. Milano: Vallardi. 1921. Reprint. Palermo: Sellerio.

————. 1919. "Confidenze degli autori," In "Italia che scrive." Anno II: December: 158.

————. 1928. "Confidenze degli autori." In "Italia che scrive." Anno XI: November: n.p.

Navarro della Miraglia, Emanule. 1963. *La nana*. Milano: Brigola, 1879. Reprint. Bologna: Capelli.

————. 1974. *Storielle siciliane*. Catania: Giannotta. 1885. Reprint. Palermo: Sellerio.

Moe, Nelson. "'Altro che Italia!' Il Sud dei piemontesi (1860–61)," Meridiana, 15, (1992): 53–89.

Odorisio, Maria Linda. 1986. *Donna o cosa? I movimenti femminili in Italia risorgimento a oggi*. Torino: Milvia Carrà.

Onofri, Massimo. 2003. *La modernità infelice: Saggi sulla letteratura siciliana del Novecento*. Avagliano: Cava de' Tirreni.

Raya, Gino. Ed. 1980. *G. Verga, Lettere a Paolina*. Rome: Fermenti.

Pausini, Cristina. 2001. *Le briciole della letteratura: le novelle e i romanzi di Maria Messina*. Bologna: CLUEB.

Pirandello, Luigi. 1957. *L'esclusa*. 1893. Reprinted in *Tutti i romanzi. Vol. 3*. Milano: Mondaori.

————. 1952. *Novelle per un anno*. Milano: Mondadori, 1952.

Sciascia, Leonardo. 1967. *Narratori si Sicilia*. With Salvatore Guglielmino. Mursia: Milano.

————. 1980. "Per terre assai lontane." In *Partono i bastimenti: L'epopea dell'emigrazione italiana nel mondo; Storie e immagini*. Ed. by Paolo Cresci and Luciano Guidobaldi. Milan: Mondadori.

————. Rpt. 1991. "Come si può essere siciliani." Vol. III. *Leonardo Sciascia: Opere 1984–1989*, Ed. Claude Ambroise. Milano: Bompiani.

————. Rpt. 1991. "Sicilia e sicilitudine." Vol. III. *Leonardo Sciascia: Opere 1984–1989*, Ed. Claude Ambroise. Milano: Bompiani.

————. 1981. "Afterword." *Casa paterna*. Palermo: Sellerio.

Verga, Giovanni. 1974. "L'amante di Gramigna." *Vita dei campi*, 1880. Reprinted in *Tutte le novelle*. Milan: Oscar Mondadori.

————. 1973. *I Malavoglia*. Milan: Oscar Mondadori.

Zambon, Patrizia. 1989. "Leggere per scrivere. La formazione autodidattica delle scrittrici atra otto e novecento: Neera, Ada Negri, Grazia Deledda, Sibilla Aleramo." In "Studi novecenteschi." 38, 287–384.

Translator's Acknowledgments

My father's parents were Sicilian, my mother's French Basque. All had come to North America as young adults early in the last century, passing through Ellis Island in search of a better life. While the stories of my mother's past were well documented and shared freely within the family, those on my father's side were shrouded in secrecy and silence. The daguerreotypes that lined my grandfather's dresser and the framed image of a hilltop town that rested beside his bed piqued my childhood curiosity. Yet my grandfather would never speak about the lovely young women in the photos, or of the lone elderly woman whose sorrowful gaze always caused me to avert my eyes.

Shortly after my grandfather's death I traveled to Sicily for the first time, determined to piece together the pasts of these women who remained behind. It was the first of many trips that I would make to the island. During the course of my post-doctoral research in the early 1980s, I came across the recently recovered short stories of Maria Messina. In those compact texts, I discovered the sad reality

of ordinary Sicilian life as my emigrant grandfather, his sisters, and mother had experienced it. The current volume reflects in part both my personal and scholarly relationship with Sicily—its history, culture, literature, and tragedy of emigration—as well as my desire to bring Maria Messina's writings to an English-speaking audience.

This work would not have been possible without assistance from many quarters. I would first like to express my debt of gratitude to the late Claudio and Giuseppina Buttà of Sant'Angelo di Brolo, Sicily, who so kindly opened their home to me when I was a student thirty years ago. Their warmth, generosity of spirit, and interest in helping me research my own family's stories, stimulated my interest in turn of the century emigration and the literature of the period. I am also grateful to the Buttà children who have continued their parents' gracious traditions and who welcome me with open arms whenever I am in Sicily.

From the outset of the project, I was fortunate to have the support of Dr. Antonino Testagrossa, Giuseppe Ciccia, and Nella Faillaci, all involved with the *Progetto Mistretta*, an organization dedicated to preserving Mistretta's rich cultural past. Their extraordinary knowledge of the town's history, willingness to grant me access to precious archival materials, and readiness to meet with me at every turn, greatly facilitated my research on Messina while I was in Sicily.

As a translator, I would like to express my gratitude to friends and colleagues Francesca Zanoncelli of Parma, Italy, Giancarlo Campolmi of Florence, Italy, and Professor Nicoletta Tinozzi Mehrmand at the University of California, Riverside, for their helpful suggestions along the way. I would also like to acknowledge Paulette Simpson of Juneau, Alaska, and Michael Baumgaertner of Stanford, California, for their thoughtful comments and careful editing of the final manuscript. My most sincere thanks, also, to Florence Howe at The Feminist Press for

recognizing the importance of Messina's works and for all of her assistance in bringing the translations to print.

This work has benefited enormously from an ongoing scholarly exchange and friendship with Professor Francesca Parmeggiani of Fordham University. Her knowledge of Italian women writers, insights into historic content, and gift for discerning linguistic nuances in both the original and translated texts, significantly enhanced the overall quality of the manuscript. In addition, her constant encouragement and sensible advice during all phases of the project were of inestimable help to me, and I will always be grateful for her guidance.

And finally, in the truest Sicilian sense of the word, I wish to thank *la mia famiglia*—my parents, my husband Joe, my children Julia, Michael, and Gabriel for their unfailing support and infinite patience.

I dedicate this translatiton to the memory of my immigrant grandparents, Michelangelo Magistro, Maria Concetta Sutera, Mathieu Etchart, and Dominica Itçaina, for their untold sacrifices and remarkable courage.